POP Art

KLAUS HONNEF
UTA GROSENICK (ED.)

TASCHEN

HONG KONG KÖLN LONDON LOS ANGELES MADRID PARIS TOKYO

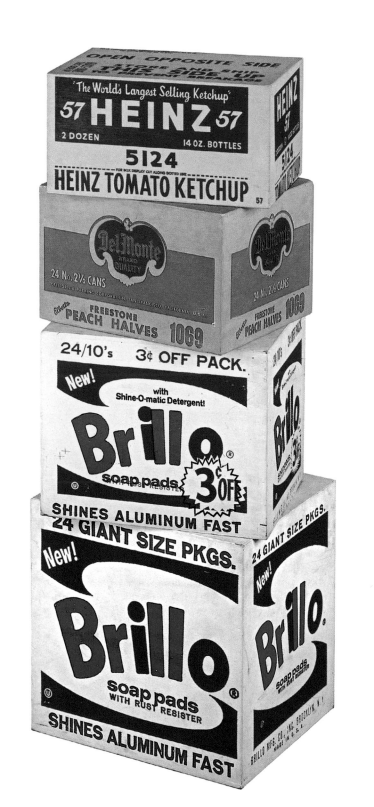

contents

POP Art

Its godfather demurred, saying he did not suggest the baby's name. At least not in the form that has since become a household name worldwide: Pop Art. Mere modesty, British understatement? Lawrence Alloway, an English art critic who later moved to New York, qualified the statement that he had coined the term Pop Art. "Furthermore, what I meant by it then is not what it means now. I used the term, and also 'Pop Culture', to refer to the products of the mass media, not to works of art that draw upon popular culture. In any case, sometime between the winter of 1954–55 and 1957 the phrase acquired currency in conversation …"[1]

By the time Alloway put this straight it was 1966, and Pop Art had long soared from its launching pad in modest shows at art schools and tiny private galleries into the orbit of the contemporary art sphere. Yet the geographic location of its success was not England, where a handful of young architects, authors, artists and intellectuals had early on discovered the charm of the brash vocabulary of the commercial mass media and established an informal committee, the Independent Group, at the Institute of Contemporary Arts (ICA) in London. The key location was the United States, where, almost simultaneously and with no knowledge of British developments, young artists began to charge the language of art with the visual jargon of the streets.

More precisely, the place was New York, and even more precisely, Manhattan. Names like Roy Lichtenstein, Claes Oldenburg, James Rosenquist, Tom Wesselmann and Andy Warhol were already being bandied about by those in the know, and Robert Rauschenberg, Jasper Johns and Larry Rivers were attracting the attention of serious collectors. Their paintings and sculptures celebrated the idiom of urban culture – advertising, comics, photography, design – with sometimes affirmative, sometimes ironical or critical intent. Suddenly a draught of vulgarity sent shivers through the elitist art scene in the world's financial capital. Yet with the emergence of Pop, New York also became the world's focus of contemporary art, supplanting Paris, which until then had set the tone in the international aesthetic concert. Ever since, the decision whether artists will find international renown, or must content themselves with a lesser reputation, has been made in the galleries and museums of Manhattan. Pop Art, moreover, appeared to be the American art par excellence – much to the chagrin of many supporters of modern art in the U.S.

From the American East Coast the wave of Pop soon spread to the Old World, creating great ripples especially in the western half of divided Germany. Collectors there either acquired entire American Pop collections or built up their own through broad-based buying, then presented them to astonished audiences in prestigious museums, even before this unfamiliar art had found a foothold in the country's galleries. Aachen, Darmstadt, other cities in the cultural provinces, and Cologne were the places where these brash works received the consecration of museum display. German artists sniffed the bracing

1955 — Signing of the Warsaw Pact **1955 — The Federal Republic of Germany becomes a member of NATO**
1955 — First "documenta", a comprehensive exhibition of modern art held every four years, takes place in Kassel, Germany

6

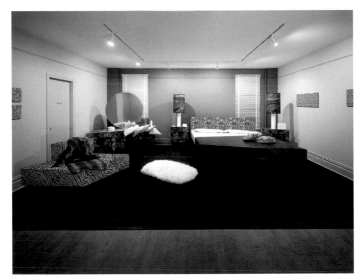
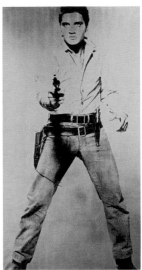

1

2

breezes and drew inspiration from the audacity of Pop imagery. Documenta 4, in 1968, brought final aesthetic legitimation for its poster-coloured pictures and sculptures in cheap materials, and Kassel, a sleepy north Hessian city not far from the demarcation line between the power blocs of West and East, outstripped Venice and its somewhat older Biennale to become the most prestigious international forum for promising tendencies in contemporary art. Probably the finest collection of Pop Art today is to be found in European rather than American museums. Though dispersed among various European nations, it is united under the patronage of its collectors: Peter and Irene Ludwig.

The enthusiasm generated by Pop ever since it first saw the light of day in small exhibitions has still not cooled. On the contrary, it has continually grown. These works still hold an undiminished appeal for young people, despite their now classical look and distance from current concerns. An artist like Andy Warhol is just as much a pop idol as the latest movie or music superstar. And not without reason. In retrospect, Warhol appears to be the most significant, because most consistent, representative of Pop Art. The only surprising thing is that despite the fact that no one seriously questions his artistic rank, he enjoys a popularity accorded to no other visual artist – with the possible exception of Picasso – and otherwise reserved largely for musicians. So one man, at any rate, has evidently succeeded in bridging the still deep chasm between demanding art and wide popularity.

From the start, an abundance of misunderstandings and misconceptions surrounded the development of a group of British and American artists who broke with many of the conventional ideas about art and yet at the same time confirmed many others, because they feared to put themselves beyond the pale of the often-quoted triangle of artist, private collector and museum. On the other hand, by this time the conceptions of art held within this territory had already become relatively flexible. Art itself had ensured this by raising a continual breaking of rules to the status of a system. Accordingly, the recent history of art could be described by its chroniclers as a permanent revolt against the time-worn and obsolete schemes of art, embodied in a long series of "isms".

The designation "avant-garde" lent a spurious uniformity to the seemingly endless sequence of unconventional works that began to shake the serious academic art world in Paris in the last quarter of the nineteenth century, and whose liberating impulses soon spread to neighbouring countries. Although many a later artist thought the term avant-garde, used so loosely as to become meaningless, ought to be given back to the military, whence it derived, it quite aptly described the attitude behind a consciously modern art. In light of this attitude, the course of art appeared to take the form of a virtually endless chain of skirmishes for ascendancy, with links called Impressionism, Divisionism, Symbolism, Expressionism, Fauvism, Cubism, Constructivism, Dadaism, Surrealism, all the way down

1955 — Billy Wilder makes the film The Seven-Year Itch 1955 — Death of Albert Einstein 1956 — Death of
Jackson Pollock in an automobile accident 1957 — In the Soviet Union, the first two man-made satellites (Sputnik I and II) are launched

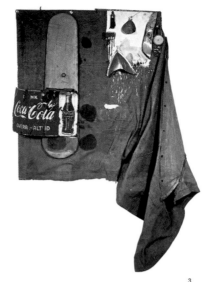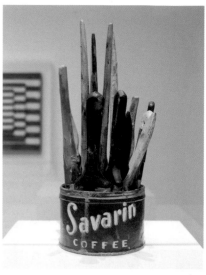

3. ROBERT RAUSCHENBERG

<u>Dylaby</u>
1962, Mixed media, 250 x 170 x 46 cm
New York, Sonnabend Gallery

4. JASPER JOHNS

<u>Painted Bronze (Savarin Can)</u>
1960, Painted Bronze, height 34 cm, ø 20 cm
In the artist's possession

5. EDWARD KIENHOLZ

<u>Portable War Memorial</u>
1968, Mixed media, 2,85 x 9,50 x 2,40 m
Cologne, Museum Ludwig

3 4

to Abstract Expressionism and L'Art informel in the immediate fore-field of Pop Art.

Art critics and historians have devoted remarkable effort and ingenuity to distilling out the various traits of these different directions and movements and declaring them to be defining stylistic characteristics. In the process they have often overlooked the underlying links between them and ultimately prepared the ground for a view of art oriented primarily to superficialities, trademark traits. In many respects, misinterpretations and misunderstandings have faithfully accompanied every one of these directions in art. And paradoxically, they have even served to markedly augment their effect. The polemics launched against the avant-garde, in particular, have had an extraordinary significance. Not all of these attacks were completely off the mark, and many turned out to be quite productive. It was no coincidence that designations like Impressionism and Cubism were originally meant derogatorily – and nevertheless took root because they pointed to traits in the art that struck the eye as typical. The present essay, too, is bound to extend the list of such actual or apparent errors in judgement.

The source of this dilemma is to be found in the works of art themselves, and it in fact represents their most important capital. The conventional wisdom notwithstanding, ambivalence is a characteristic trait of art. Ambivalence is that multiplicity of meaning which enables art to overcome its ties with its own period. Ambivalence should not be confused with arbitrariness. Works of art would be arbitrary if they provided a clear answer to every conceivable question or challenge. Works of art change their nature depending on the point of view from which they are seen, and yet nevertheless retain a validity that transcends the idiosyncrasies of time. Some people see an aspect of the absolute in this.

Robert Rauschenberg, generally considered one of the fore-runners of Pop, is said to have stated that he had never seen a more beautiful sculpture than Marcel Duchamp's urinal, titled *Fountain*. By saying this, of course, Rauschenberg stood the French artist's intention on its head. By presenting a vulgar utilitarian commodity in an art exhibition, the second Armory Show of 1917 in New York, Duchamp hoped to provoke a certain reaction. His aesthetic goal was to replace an art designed to please the eye – he called it "retinal art" – with an art of the intellect. Not the object as such was important to him but the train of thought it would touch off in the context of an unfamiliar environment. Thanks to Rauschenberg's fruitful misunderstanding, the Frenchman and naturalized American was suddenly installed in the geneology of Pop, as if he were interested in the trivial everyday world rather than in challenging the art world. Though obviously misunderstood, Duchamp never protested. And since there is no evidence to prove that the original *Fountain* ever actually existed, or whether the management of the non-juried exhibition who rejected it despite previous agreement might not have been fooled by a rumour launched by

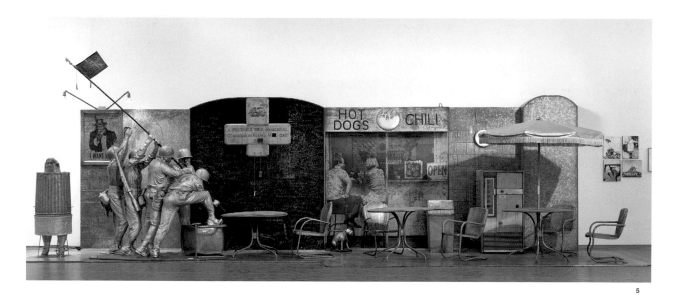

5

Duchamp, he is moreover claimed to be a father of that art of ideas known as Conceptual Art.

It was likely no accident that the hour of birth of the avant-garde coincided with the expansion of the modern press and publication industry. One of the most crucial consequences of this development, as far as art was concerned, was the emergence of the professional art critic, who was no longer an artist and whose activity required neither artistic training nor artistic talent to pursue. The noisy battle that ensued among art critics advancing their arguments pro and con in increasing numbers of periodicals created a bridge to a growing audience. From then on, critics' opinions shaped, even became, public opinion. This development had been preceded by a fundamental change in the structure of public affairs, when the bourgeoisie became their vehicle. If previously the strict rules of an aristocratic *ancien regime* had determined the course of public affairs, now an exchange between citizens who were equal before the law began to shape the social and cultural climate. Although avant-garde artists never wished to, or could, entirely identify with middle-class tastes, they acted on the same cultural terrain, paradoxically tilling it all the more intensively the more violently they reacted against its supposed barrenness.

Leading artists have again and again spoken in simple and clear terms about their works and the ideas they wished to convey through them. Yet they were seldom listened to. In the version of their self-styled interpreters, who soon donned the mantle of expertise, artists' intentions invariably took on a more complicated, profound and mysterious air than in their own explanations. As a result, critics' statements enormously increased the impact of the artistic tendencies in question and attracted the attention necessary to make them topics of public discussion. Sometimes artists defended themselves against all-too glaring critical misconceptions, but they generally avoided a sharp counterattack when they realized how useful the critics actually could be. Artists are pragmatic people.

His profession of art critic notwithstanding, Lawrence Alloway attempted to defend Pop against the misconceptions and dubious conclusions that had already begun to circulate back then. "Pop Art has been linked to mass communication in facetious ways as well as in straight arguments: references to the mass media in Pop Art have been made the pretext for completely identifying the source with its adaptation … There is a double flaw in the argument: an image in Pop Art is in a new context … and this is a crucial difference; and, in addition, the mass media are more complex and less inert than this view presupposes."[2] For British artists, at least, this held true. Although they discovered a previously almost unexploited repertoire in the visual storehouse of commercial culture, they subjected it to their own personal view and transformed it aesthetically. For the Americans, on the other hand, Alloway's statement holds only with qualifications, and by no means for all of them. Yet the British critic's remarks do touch upon

1958 — "EXPO 58" in Brussels 1958 — Mies van der Rohe builds the Seagram Building in New York
1959 — The Boeing 707 airliner reduces the flight-time from Paris to New York to eight hours

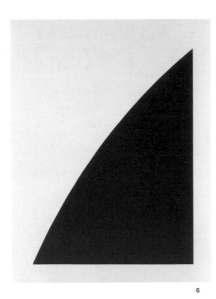

6 7

the decisive issue. It remains a matter of opinion whether one considers Pop Art just another artistic direction that existed largely within the familiar framework of modern art, or a movement that exploded this framework and opened the door to a new art and a new conception of art. To put the question differently, does Pop represent one of those many variants of modern art which have continually expanded its range into previously unconsidered areas of human life, or does it mark a break with the art of the avant-garde and possibly a conscious or unconscious reversion to artistic ideas to combat which the avant-garde formed ranks in the first place?

As clear as the alternatives might seem, it would be naive to assume that an equally clear answer to this question could be derived from the practice of art. Nor has the issue ever been a matter of either-or, neither for artists nor for their contemporary viewers. As regards Pop, the question can only be answered with a clear "both-and". Especially seeing as the great majority of the artists and critics involved agreed, beyond all of their differences, that Pop fit seamlessly into the picture of the avant-garde, a picture marked by baffling leaps and glaring contradictions anyway.

To quote Lucy R. Lippard, one of the most committed advocates of this art shot through with commercial trivialities like comic strips, press photos, movie star clichés, cinema marquees, foodstuffs of papier maché and plastic, "Pop Art has more in common with the American 'post-painterly abstraction' of Ellsworth Kelly or Kenneth Noland than with contemporary realism. When Pop first emerged in England, America, and Europe, raised eyebrows and indignation were accompanied by a profound disappointment on the part of many artists and critics. This unexpected outcome of a decade of Abstract Expressionism … was hardly a welcome one, since it dashed hopes for the rise of a 'new humanism', known as the 'New Image of Man' in America and 'New Figuration' in Europe. Man might make an occasional appearance in Pop canvases, but only as a robot remotely controlled by the Consumers' Index, or as a sentimentalized parody of the ideal. For other observers, however, such a brash and uncritical reflection of our environment was a breath of fresh air."[3]

Two aspects of this passage deserve closer attention. The first is Lippard's opinion that Pop possesses a greater affinity with the abstract art of Kelly or Noland than with conventional approaches such as realism; the second culminates in her characterization of the reaction of the broad masses to Pop, as one of indignation, frank rejection. Unfortunately Lippard does not give any reasons for this rejection. It would seem surprising that most people should have rejected Pop despite the fact that its vocabulary and materials must have been entirely familiar to them from their daily encounters with things of this sort. Or perhaps this itself was the reason? Might not people's negative reaction to Pop pictures and sculptures have resulted from their quite different notion of what art should consist of and convey — whether spiritual edification or a type of aesthetic experience long since

--

1959 — Günter Grass writes the novel The Tin Drum
1959 — Jean-Luc Godard, French New Wave film director, makes Breathless

--

6. ELLSWORTH KELLY

<u>Red Curve</u>
n. d., Lithograph, 81 x 61 cm
Private collection

7. KENNETH NOLAND

<u>Provence</u>
1960, Acrylic on canvas, 91 x 91 cm
Cologne, Museum Ludwig

8. GEORGE SEGAL

<u>Portrait of Sidney Janis with Mondrian Painting</u>
1967, Mixed media, 177 x 143 x 69 cm
New York, The Museum of Modern Art,
Sidney and Harriet Janis Collection

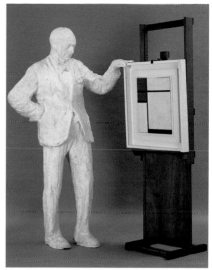

8

schooled on avant-garde art, with which Pop brutally collided? In terms of the then-current model of incessant artistic progress, apparently confirmed by avant-garde developments, the advance of modern art led almost automatically to pure abstraction. Accordingly, Lippard is concerned to place the works of Pop artists, as it were, under the protective aesthetic umbrella of abstraction, so as not to jeopardize their progressive status. It is indicative that she dissociates her protégé from realism in art, but not from the potential temptations of the commercial media, which supplied Pop Art with its subject matter, themes, and in many cases its mode of depiction. Her motive is not hard to understand. If the many, various and often controversial approaches of the avant-garde have any common denominator, it is their innate hostility towards every variant of realism. It should not be forgotten that when Lippard penned her analysis, one of these variants was politically still very much alive. This was the wretched doctrine of "socialist realism". The Soviet Union and its satellites still represented an acute threat to the capitalist hemisphere. The Cold War still cast its shadow over the art scene.

Not surprisingly, in their verbal statements artists of the day confessed their undivided allegiance to the avant-garde. Many of them had tried their hand, without much success, as third-generation Abstract Expressionists, and all of them had enjoyed a formal art education. Jim Dine, whose contacts with Pop Art were on the sporadic side despite his employment of motifs such as giant neckties and the fact

that many considered him a Pop artist, demurred when asked in an interview about his links with an art based on a popular repertoire. "I don't feel very pure in that respect", said Dine. "I don't deal exclusively with the popular image. I'm more concerned with it as part of my landscape. I'm sure everyone has always been aware of that landscape, the artistic landscape, the artist's vocabulary, the artist's dictionary." To preclude overhasty conclusions, Dine then added that he did not believe Pop represented a "sharp break" with Abstract Expressionism, nor that it replaced it.

And Roy Lichtenstein, another American, despite his exploitation of the visual impact of popular comic strips in his art, denied any artistic affinity with their makers, instead citing experimental forms of art as his source of inspiration. He was thinking more of the happenings of Oldenburg, Dine, Whitman and Kaprow, Lichtenstein explained. Though he had not seen many happenings, they seemed to him to concern themselves with American industrial development. And Pop Art, he added in another place, was "actually industrial painting … I think the meaning of my work is that it's industrial, it's what all the world will soon become."

Only Warhol, who had begun to produce paintings by a commercial silkscreen process early on, relinquished this defensive stance. He brashly declared, "I think it would be so great if more people took up silk screens, so that no one would know whether my picture was mine or somebody else's." When the interviewer asked

1960 — Beginning of the Ten Power Disarmament Conference in Geneva, where Eastern and Western powers reject each other's disarmament proposals 1960 — German architect Hans Scharoun builds the Philharmonie in Berlin

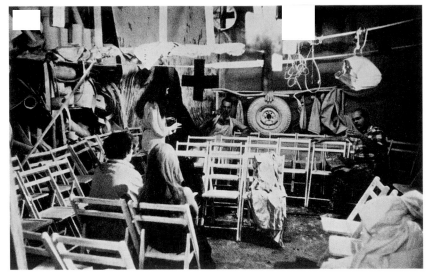

9. ALLAN KAPROW
Rehearsal for the happening "Car Crash"
by Jim Dine, 1960

10. ANDY WARHOL
<u>Big Torn Campbell's Soup Can (Vegetable Beef)</u>
1962, Oil on canvas, 274 x 152 cm
Private collection

11. ROBERT INDIANA
<u>Love Rising</u>
1968, Acrylic on canvas, 4 panels, 370 x 370 cm
Vienna, Museum moderner Kunst –
Sammlung Ludwig

9

whether this would turn art history upside down, Warhol simply replied, "Yes". The three artists quoted represented different variants of Pop, and Lippard counted only Lichtenstein and Warhol among its hard core, but not the vacillating Dine. "And although he is frequently included in the Pop rosters", she explained, Dine's "every work and statement show him to be worlds apart from that touch iconoclasm and formal emphasis."

All in all, the statements made by most of the artists involved would seem to confirm the findings of Alloway, Lippard and the majority of commentators, who imply that Pop represented merely one of the many mutations of contemporary art. Seen in this light, Pop by no means, as Warhol suggested, subverted the self-image of modern art. So it is all the more surprising to find influential critics occasionally railing against this particular variant. Lippard mentioned them only summarily and in passing. Yet these were critics who had proved themselves knowledgeable and courageous advocates of the avant-garde. A podium discussion in New York, in which heavyweights of criticism and art history participated, is a revealing case in point.

On September 13, 1962, the Museum of Modern Art held a symposium on Pop Art, for no visible reason, neither an exhibition nor a purchase having occasioned it. Thanks to its exemplary collection and its groundbreaking modern exhibitions, the museum had long gained an international reputation as an unsinkable avant-garde flag-

ship. The early date of the symposium was nevertheless surprising. At the time, Pop had hardly spread beyond the small, 10th-Street galleries where works of its protagonists had been shown. It had not yet arrived at the better Manhattan galleries. Nor had the term Pop yet entered common usage. It was still vying for acceptance with other names, such as Neo-Dada, New Sign Painting, or New American Dream. The painting and sculpture department of the Museum of Modern Art owned only six works in the genre. Nor did the two curators responsible for painting and sculpture, the legendary Alfred H. Barr, Jr., former director of the museum, and the competent Dorothy C. Miller, deem it necessary to attend the symposium. Nevertheless, it was to have far-reaching consequences, not only for the renowned museum on 46th Street.

The camp of Pop enthusiasts was underrepresented on the podium. In truth, it consisted of only a single person: Henry Geldzahler, a young assistant curator at the Metropolitan Museum of Art. Peter Selz, who had organized the meeting and worked at the time as curator in the MoMA exhibitions department, was quite frank about his scepticism regarding Pop. The other participants either took a waiting stance or opened their critical fire on the Pop artists' aesthetic positions. Hilton Kramer, conservative star critic of the New York Times, even imputed that the fact the symposium was even being held reflected a bald-faced bias in favour of Pop. Yet in the crossfire of opposing opinions one, key question stood out: Is Pop Art art at all?

1960 — Oscar Niemeyer begins construction of Brasilia, the new capital of Brazil

1960 — Alfred Hitchcock makes the film Psycho　　　　**1960 — The advent of "Nouveau Réalisme" in France**

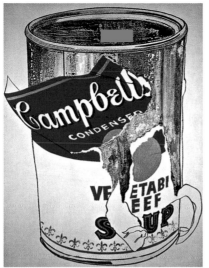

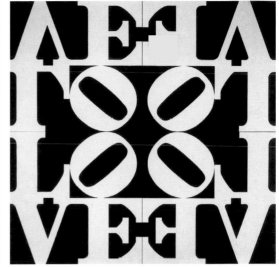

10 11

And by art, the participants meant exclusively modern art, the art of the avant-garde. According to their virtually unanimously held view, the avant-garde represented an art liberated from the mode of depiction, or in expert jargon, "non-representational" art. The standards of aesthetic expression were set solely by art itself. Artists were precluded from looking at reality, and every attempt to artistically and aesthetically digest real impressions had fallen under the curse of the unartistic and historically outmoded. In the work of a true artist, the outside world had no role to play. While Selz censured Lichtenstein for having supposedly translated comic strips "almost directly"[4] into his paintings, the poet, critic and Pulitzer prizewinner Stanley Kunitz accused Warhol's pictures of Campbell's Soup can labels of having been mechanically reproduced without the aid of a pencil. Geldzahler's objection that Lichtenstein, at least, had made artistic incursions into the structure of his patterns was greeted by general laughter, then countered by the art historian and famous author Dore Ashton, who maliciously replied that he, Geldzahler, could only have observed that through a magnifying glass.

In the eyes of its prominent opponents, Pop lacked revolutionary elan in the artistic sense. Its "signs and slogans and strategems come straight out of the citadel of bourgeois society", averred Kunitz, "the communications stronghold where the images and desires of mass man are produced." Then Selz struck a further blow, alleging that Pop artists represented "the spirit of conformity and the bourgeoisie".

Hilton Kramer summed up the objections with a connoisseur's eye, declaring that Pop was "indistinguishable from advertising art". Both ultimately attempted to "reconcile us to a world of commodities, banalities and vulgarities". In view of such intentions, Kramer insisted that Pop Art must be resisted at all costs.

Above the heads of the debaters hovered, like a kind of superfather, the powerful Clement Greenberg. A profound and eloquent critic and man of learning, Greenberg had once provided the theoretical underpinnings for American abstract art and, with his essays and subtle influence, had materially contributed to its worldwide reputation. And though the heyday of Abstract Expressionism was long over, his influence remained unbroken. What Greenberg said and wrote may no longer have had the power of law, but it still carried incredible weight. As early as 1939, in an epoch-making essay titled "Avant Garde and Kitsch",[5] which by the time of the symposium had gone through several reprints, Greenberg had forged the intellectual weapons in defence of an art cleansed of all non-artistic ingredients. His carefully polished and convincing arguments were now repeated, in coarser form, by the opponents of Pop.

But it was not only their acumen that made Greenberg's hypotheses as interesting now as they were when published over half a century ago. It was the circumstance that Pop relegated them to the museum of art theory. Why was this so? While Pop swept Greenberg's definition of art aside, it was only against its background that the fun-

1961 — Ernest Hemingway commits suicide 1961 — John F. Kennedy inaugurated as president of the United States
1961 — August 13: The German Democratic Republic raises a wall between East and West Berlin

13

12. LARRY RIVERS
<u>Friendship of America and France</u>
<u>(Kennedy and de Gaulle)</u>
1961–1962, Oil on canvas, 130 x 194 x 11 cm
Courtesy Marlborough Gallery Inc., New York

12

damentally new and different nature of Pop became graphically apparent. What sounded like a paradox lost its paradoxical character when the areas Greenberg categorically excluded from his definition suddenly became the focus of attention.

With consciously polemical intent, Greenberg projected the German term "kitsch" onto the visual phenomena of mass culture. "Simultaneously with the entrance of the avant-garde", he wrote, "a second new cultural phenomenon appeared in the industrialized West: that thing to which the Germans give the wonderful name of Kitsch: popular, commercial art and literature with their chromeotypes, magazine covers, illustrations, ads, slick and pulp fiction, comics, Tin Pan Alley musicals, tap dancing, Hollywood movies, etc. etc." It was time, Greenberg added, to inquire into the why and wherefore of this long-neglected phenomenon. Disregarding a few of the genres on Greenberg's negative list, its items add up to the preferred repertoire of Pop Art.

Saleability was and still is the Mark of Cain of popular culture. The critic admitted it could be tempting even for serious artists: "Kitsch's enormous profits are a source of temptation to the avant-garde itself, and its members have not always resisted this temptation … The net result is always to the detriment of true culture, in any case." Though in the leftist political camp at the time his essay was published, Greenberg could not resist swinging the moral cudgel against an art of popular appeal. The true avant-garde artist or writer

who remained uninfluenced by the commercialism of his environment would "maintain the high level of his art both by narrowing and raising it to the expression of an absolute in which all relativities and contradictions would be either resolved or beside the point. 'Art for art's sake' and 'pure poetry' appear, and subject matter or content becomes something to be avoided like a plague."

Greenberg always remained faithful to these aesthetic maxims, which were suffused by the sublime light of German idealistic philosophy. And far from being the product of his own private tic, in one form or another they dominated the Western art scene until the appearance of Pop. Whether current aesthetic notions were based on a rigidly grounded theoretical conception of the kind Greenberg formulated or merely on the idea of modern art being a never-resting assembly line that produced innovation after surprising innovation, was immaterial. Everyone had to agree with Greenberg when he declared that "Picasso, Braque, Mondrian, Miró, Kandinsky, Brancusi, even Klee, Matisse and Cézanne, derive their chief inspiration from the medium they work in. The excitement of their art seems to lie most of all in its pure preoccupation with the invention and arrangement of spaces, surfaces, shapes, colors, etc., to the exclusion of whatever is not necessarily implicated in these factors."

Not that Pop artists threw space, plane, form and colour by the wayside – in the beginning, at least, they attempted to transcend this self-referential system and throw open the window of an all-too her-

1961 — The Beatles make a guest appearance in the Star Club, Hamburg
1961 — April 12: First manned space flight by the U.S.S.R., piloted by Yuri Gagarin, orbits the earth

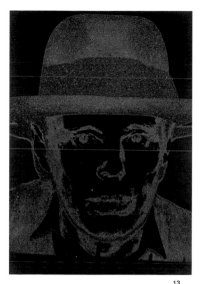

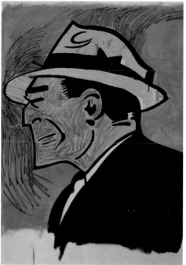

13 14

13. ANDY WARHOL

<u>Joseph Beuys</u>
1980, Silkscreen, 111 x 76 cm
London, Arts Council Collection, Hayward Gallery

14. ANDY WARHOL

<u>Dick Tracy</u>
1960, Casein and coloured pencil on canvas,
122 x 86 cm
Private collection

metic art to admit the fresh air of the streets. Nor was this by any means the first time a direction in art had turned to the hustle and bustle of ordinary, everyday life. Long before art had shed the fetters of purpose and service to be nothing but art, it had turned an eye to the visible and invisible phenomena that existed beyond the picture frame. In each case, admittedly, different levels of risk were involved. While still in the service of the church and the secular aristocracy, art celebrated their attitude towards God and the world. In the service of the bourgeoisie, it depicted the bourgeois view of the world and the things this stratum found essential. Modern art, in turn, derived its reason for being from the certainty of having liberated itself from such strictures, despite the fact that many of its detractors considered this a hypocritical assertion and maintained that art was released from its previous obligations because its tasks could be more effectively performed by technical media such as photography and film, and commercial forms of communication like advertising, illustrated magazines and comic strips. Yet one thing was undeniable: since the emergence of what Greenberg called a "second new cultural phenomenon" and its mass dissemination, art has established itself as an autonomous cultural phenomenon whose involvement in the relationships of visible and experienceable reality is indirect at best.

Anyone who sets out to find a historical point of departure for Pop is bound to arrive at Dada or Duchamp. The parallels are more than obvious. Thanks to intelligently composed snippets, the firma-ment of commercial imagery already shone in the Dada collages of Raoul Hausmann and Hannah Höch, George Grosz and John Heart-field. Max Ernst's phantasmagorical universe was shaped of cuttings from popular illustrations. Scissors and paste replaced brush and paint, and illustrated magazines supplanted the media of art. Kurt Schwitters, the German Dadaist, built a house of waste and discarded materials inside his Hanover apartment and titled it *Merz*. Evidently Dada targeted the art of the bourgeoisie, especially the kind based on education and good taste. In the minds of its protagonists, Dada was to be a "slap in the face" of self-satisfied respectable citizens. Dada was intended to wipe the slate clean of them and their culture. Was Pop in a comparable cultural situation when it emerged?

Hardly, either in a political or an economic sense. Incidentally, even the most pointed works of the Pop artists reflect a complete absence of political intent. Criticism of the injustices of capitalist society is found only rarely, and even then it does not undermine the social consensus. At best it lays bare the hidden mechanisms of society. On the other hand, the discovery of mass culture by Pop artists was preceded long before by the Cubists, who pasted news-paper clippings into their paintings, or the American artist Stuart Davis, who depicted a bottle of mouthwash in his painting *Odol*, 1924. The list of possible predecessors could be extended without ever once breaking the taboo by mentioning a realist. Nor did any Pop artist in the United States ever dream of singing the praises of

1962 — Cuba Crisis 1962 — Death of Marilyn Monroe 1962 — First manned U. S. space flight
 1962 — Telstar, the first communications satellite, is launched 1963 — The Fluxus Movement in Germany

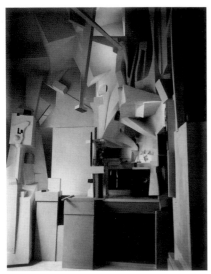

15

anarchy. Only the underground cinema movement, to which Warhol contributed several remarkable works, confessed its allegiance to aesthetic revolt and jettisoned the conventions of narrative and art cinema in the process.

That the works of British Pop artists were dominated by a frank fascination with the brash factory-made imagery of consumption and the culture of commerce, was not surprising. While the United States experienced a phase of economic prosperity in the 1950s and 1960s and private consumption reached record peaks, Great Britain's economy recovered only slowly from the devastating consequences of World War II. The situation improved even less quickly than in West Germany, the land of the vanquished. When the dreary London streets were gradually brightened by the glamour of commercial advertising and the dreams of Hollywood, artists were as unable to resist their spell as the broad public.

Richard Hamilton, who had made replicas for Duchamp, encountered the visual temptations of consumer culture with mixed feelings. His collage, *Just what is it that makes today's homes so different, so appealing?*, 1956, a wonderful early example of the aesthetic watershed, brought standard figures from the realm of trivial imagery into a modern overfurnished apartment. The work was intended for publication in the catalogue for the exhibition "This is Tomorrow", held at the Whitechapel Gallery, London, in 1956. It also served as the poster motif. Although "This is Tomorrow" was not a show of nascent Pop Art, it provided decisive impulses. The exhibition consisted of twelve separate displays in which the participants, principally architects and urban planners, were able to realize their ideas at their own discretion. The interesting thing was that they drew attention to the visual environment of contemporary civilization. The results were astonishing, said Hamilton, ranging from purely architectural pavilions through department-store displays to a turbulent, incredibly exciting fun-fair architecture. The enterprise was a true eye-opener, revealing previously unknown horizons for artistic developments to come. Moreover, "This Is Tomorrow" underscored the increasing significance of exhibitions for the public dissemination of art. Exhibitions were soon to become key loci in which isolated artistic initiatives condensed into manifest trends.

To his way of thinking, Hamilton noted, the point of the exhibition was not so much to find art forms as to test values. The Independent Group opposed those who were primarily concerned with "creating a new style". They rejected the notion that "tomorrow" could be expressed by establishing rigorous formal concepts. "Tomorrow" would merely expand present-day visual experiences. What was needed, Hamilton continued, was not a definition of the serious work of art but the development of a potential perspective, in order to be able "to accept and apply the continual enrichment of visual material". All of the work of British Pop artists, including Hamilton, since the 1950's, said Alloway, showed that they "accepted

--
1963 — President John F. Kennedy assassinated in Dallas, Texas **1963 — Race riots shake the U. S.**
1963 — Ingmar Bergman makes the film Silence
--

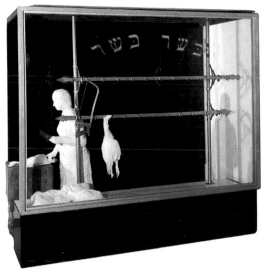

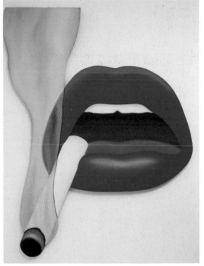

16

17

industrial culture and assimilated aspects of it into their art" in an eclectic and all-embracing way.

The artists had no intention of denying the primacy of art in dealing with the visual challenges of mass culture. Instead, they set out to adapt a largely unexploited repertoire, material, as Hamilton called it, from advertising, movies and television which could be used to infuse new life into "high" art, whose once compelling power seemed on the wane. By so doing, Hamilton, like every like-minded artist, committed a sacrilege on Greenberg's definition of the avant-garde. He focussed on the *effects* of artistic possibilities. "If the avant-garde imitates the processes of art, kitsch … imitates its effects", decreed Greenberg. The slightest contact with commercial culture would infect art and irreparably sully the purity of the artist's intentions.

Actually, Hamilton went only a small step beyond Francis Bacon. Bacon had incorporated into his paintings still photos from Sergei Eisenstein's legendary film *The Battleship Potemkin,* 1925, and stop-motion photographs by Eadweard Muybridge. He reworked them without concealing their origin. Bacon's use of such material was highly regarded in the art world. Hamilton, unlike Bacon, did not alter the structure of his photographic material but combined various photographic elements into a different photographic reality from that manifested in the original material. A case in point is *My Marilyn,* 1964. This series of photos of the film star Marilyn Monroe in a bikini on the beach was based on a sheet of contact prints. A few of these

were partially painted over and alienated mechanically or by hand. In other pictures, the photographic originals were modified into soft, painterly forms recalling cosmetic ads. Yet despite appropriating visual clichés, the images of consumer culture, Hamilton retained his detachment.

Especially continental European critics tended to imply that British Pop artists were critical of mass media imagery. In general, the actual works do not warrant this view. Admittedly Peter Blake, Richard Smith, Derek Boshier, Patrick Caulfield, David Hockney, Allen Jones and Peter Phillips did address the visual forms of popular culture to varying extents and with different intents, and Eduardo Paolozzi, not a true Pop artist at all, paid tribute to some of the more fantastic aspects of modern civilization with his brightly coloured robots. But they all blended selected set pieces from the commercial idiom into a subjective artistic language and reshaped them in terms of their personal vision, yet without resorting to an expressive approach to package their message. Their gestures were cool and objective, almost abstract, or as if borrowed second-hand. In terms of their artistic procedures, their impersonal and prefabricated touch, they were related to the hardcore American Pop artists Oldenburg, Lichtenstein, Rosenquist, Wesselmann and Warhol.

In his painting *On the Balcony,* 1955–57, Peter Blake arrayed the entire arsenal of industrially produced imagery: magazine covers from *Life* and *Weekly Illustrated,* picture postcards, photos of pop

1963 — **First high-speed 35mm camera, the Instamatic, marketed by Kodak**

1964 — **The Labour Party comes to power in Britain**

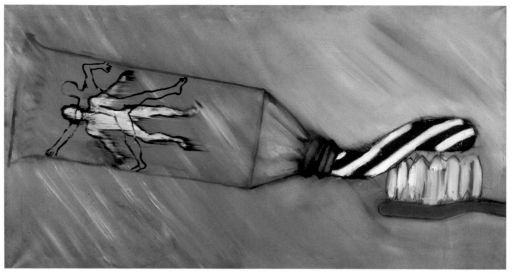

stars, a parade of royals, a picture of Sir Winston Churchill with King and Queen, a caricature. On the same level he arranges reproductions of paintings, including Manet's *Balcony,* 1868. These are accompanied by mundane commodities such as a half-empty bottle of mineral water or soda pop, a margarine package, a newspaper, and many others. The provocation lies in the mixture. Everything is painted with equal attention to detail. The result is a painting of extraordinary aesthetic delicacy, a painted collage, and, if you will, a clever retranslation of a "progressive" artistic technique back into Old Masterly terms.

Richard Smith, who would soon move to the U.S., combined the achievements of abstract art with the brash visual impact of consumer imagery. Cigarette packs and shipping cartons for industrially manufactured foods inspired him to gigantic, illusionistic paintings from which direct allusions to the visual vocabulary of the mass media were expunged. Sometimes he trimmed the format of his painted pictures into shapes that, again repainted, suggested three-dimensional objects.

Derek Boshier conserved traces of expressive painting, inoculated with a touch of irony. In *First Tooth Paste Painting,* 1962, he applied the silhouette of a sprawling, apparently male figure onto a toothpaste tube projecting from the left into a light-blue field. On the right, the toothpaste is being squeezed in garish red and white stripes onto a green toothbrush. Like Blake, Boshier is an excellent painter, and it is unlikely that he ever considered sacrificing the qualities of his craft to the power of commercial imagery. According to one commen-

tator, his paintings "might be called visions of negative utopias. The technological achievements and prefabricated models consume or engulf the individual" (Tilman Osterwold). Smith, a friend of Boshier's, took a more down-to-earth view. Though Boshier's pictures were "social comment", he explained, it was in "mad, comic terms. Billy Wilder says, 'One thing I dislike more than being taken too lightly is being taken too seriously.'"

Allen Jones brought the fury of the feminists down upon his head. Like Pop in the cultural arena and the election of John F. Kennedy to the presidency in the political one, the burgeoning of the women's movement was a sign that fossilized structures in the social edifice of the Western world were beginning to break up. When Jones emphasized the breasts, buttocks and legs of his female models to the point of fetish worship, the verdict was clear: sexism. Later he even converted specially fabricated female shop-window dummies into tables and chairs – a dubious invitation, it seemed, to the exploitation of women. Still, Jones' objects did not leave the familiar system of art, they merely stretched it to the breaking point. He denied having been inspired by commercial imagery. A head with a necktie under it, Jones averred, was a "phallic totem image", and thus not a part of "popular iconography".

Private notions and obsessions were likewise the motive force behind David Hockney's artistic universe. His apparently childlike graphic style lent his pictures an aura of carefree innocence, and their

1964 — Beginning of the Vietnam War

1965 — Death of Le Corbusier

1965 — Jean-Paul Sartre rejects the Nobel Prize for Literature

1965 — The U.S. increases its military engagement in Vietnam

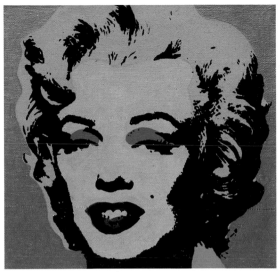

19

18. DEREK BOSHIER
First Tooth Paste Painting
1962, Oil on canvas, 76 x 137 cm
Sheffield, City Art Galleries

19. RICHARD PETTIBONE
Andy Warhol – Marilyn Monroe
1968, Silkscreen on canvas, 13 x 13 cm
New York, The Museum of Modern Art,
Frances Keech Bequest

often bright illumination a touch of unreality. Geldzahler, a friend to whom Hockney devoted a few portraits – including *Henry Geldzahler and Christopher Scott*, 1969 – doubted that the artist had any affinity with Pop Art. His reasoning was surprising, since it detached Hockney's work from contemporary influence. His "sources and exemplars", said Geldzahler, "are more likely to be the poets George Herbert and Andrew Marvell or Degas and Toulouse-Lautrec than this morning's headlines. Curious as he is intellectually, he has little room in his working aesthetic for the cascade of data that crackles about us like static."[6] Except for a handful of early works, Hockney painted no definitely Pop pictures. *Tea Painting in an Illusionistic Style,* 1961, was one of them, a clever, shaped canvas like a tea box for a race of giants.

None of the British artists of his generation devoted himself more uncompromisingly to the spirit and look of commercial culture than Peter Phillips. With Boshier, Jones and Hockney, Phillips represented the third wave of Pop in England and, taking its cue from the widely respected Hamilton, the second wave with a figurative tendency. Phillips' characteristic paintings adapt the bizarre configurations of the illuminated decor on pinball machines with their lightning flashes and aggressively tempting pin-up girls, and blow them up to a format that veritably blasts the viewer with an incessant fire of visual stimuli. During a two-year stay in New York (1962–64), Phillips bought an airbrush of the kind he had long considered using and began to execute his cool imagery with a technique equally as detached. Using a

machine, as Christopher Finch explained, was a logical, almost unavoidable expansion of Phillips' previous painting methods. The even clearer and more intensive immediacy of his visual language was likely one result of this airbrush technique. With his radical waiver of personal touch, his frank idolization of commercial imagery, and his use of unusual formats, Phillips was not only the most rigorous of British Pop artists but the one with the greatest intellectual and visual affinity to the Americans. Only Caulfield was similarly rigorous in approach.

What distinguished the American artists from the British, their unfiltered Pop ideology, was the result of a break between cultural developments in the U.S. and the European tradition. At exactly what point in time this occurred, cannot be said with certainty. At any rate, the break was provoked and furthered by the burgeoning of that commercial culture which Greenberg denounced as "kitsch". By using this polemical label, Greenberg laid as false a trail as Alloway, who preferred the kinder term "folk culture".

Popular culture, which from another point of view figures as mass culture, is neither the result of local cultural traditions nor a growth springing from the midst of the people. It is a product of the increasing industrialization of Western societies, and governs their relationships and mechanisms. Oriented towards the expectations of urban consumers, popular culture reacts seismographically to potential changes in collective moods and behaviour. Its originators are professional designers – artists, if you will – who work on commission

1965 — Development of the programming language Basic
 1966 — Various German student and other groups join forces in the Extra-Parliamentary Opposition (APO)

20

and must adjust their individual ideas to conform with those of their clients. They might be compared to artists before the advent of the avant-garde, such as the members of medieval building associations or early modern guilds. Like theirs, the activity of contemporary professionals is conducted on the basis of a division of labour, and they have no control over the final product of their work.

Industrially organized production of culture has always seemed suspect to committed cultural critics. For Max Horkheimer and Theodor W. Adorno, it represented an instrument of subtle oppression in the hands of those who possessed and administrated economic and political power. Its products served only one purpose – to draw people's attention away from their true interests and, by colonizing their minds, divert it towards superficial, surrogate pleasures. Beyond this, the mass production of standardized commodities and ideas, aimed at the lowest common denominator, would lead to a gradual decline in the general intellectual level. Greenberg thought similarly.

In view of commercial movies, René König reached a more differentiated conclusion. "If the effect of the mass nature of film and television presentations is in fact a massing of the audience, then this must be based on the assumption either that their effect falls everywhere on the same soil or that the recipients are completely passive."[7] The first assumption was unfounded, said König, because viewers and their mentalities were integrated in numerous different social spheres and differed in terms of sex, age, occupation, income and cultural atti-

tude; the second assumption was unfounded because only certain people went to the cinema and not even they reacted uniformly to what it offered. By comparison with the traditional arts, moreover, film had the advantage of possessing a considerably greater range. It provided a crystallization point not necessarily for "manifest mental moods and ideas reduced to solid formulae, but, and especially, for the latent, frequently subliminal attitudes and expectations … of the collective unconscious."

Lichtenstein, Oldenburg, Rosenquist, Wesselmann and Warhol were probably more or less avid moviegoers. But they were definitely habitual beneficiaries of the American Way of Life. In addition, during, after or in parallel with their art studies, all of them practised commercial art, either voluntarily or as a way of earning a living. Lichtenstein gained experience as a technical draughtsman and designer of windows and sheet metal products. Oldenburg, from a well-off family, tried his hand at journalism and published drawings in illustrated magazines. Rosenquist worked as a billboard painter for a time, and Wesselmann studied cartooning. The best-known and most successful commercial artist among them was Warhol, who did brilliant, mannerist drawings for shoe ads. "Yet all of them", as Lucy Lippard explained, "were artists first and foremost, devoting their energies to serious painting … They have all steered away from the slick advertisement that imitates the modern fine arts." Their ambitions helped trigger the abrupt transformation of the art scene known as Pop.

--

1966 — Michelangelo Antonioni makes the film Blow Up

1966 — Start of the Cultural Revolution in China

1966 — Minimal Art makes its appearance in the galleries

1966 — Happenings become an art form

--

20. PATRICK CAULFIELD

Artist's Studio
1964, Oil on wood, 91 x 281 cm
London, The Arts Council of Great Britain

21. DAVID HOCKNEY

Henry Geldzahler and Christopher Scott
1969, Acrylic on canvas, 213 x 305 cm
Private collection

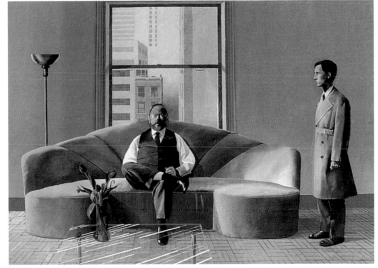

21

If, in the early modern era, journeymen were furthered by their masters and introduced to potential clients, in the bourgeois period students were helped by their teachers, and in the modern age artists were publicized by writers and critics. Since the advent of the avant-garde, art dealers have had an increasing influence on the vicissitudes of the art scene. Abstract Expressionism owed its overwhelming international resonance not least to a powerful alliance of eloquent artists, intelligent critics like Greenberg, Harold Rosenberg et al., and strategically clever art dealers with a sense of artistic originality and energy, willingness to take risks, and force of character. Under the aegis of the avant-garde, the art trade emerged from its previous role of behind-the-scenes intermediary to become a key player on the stage of art.

In the 1940s and 1950s, young experimental artists and audacious dealers moved into the former industrial lofts in downtown Manhattan, a once vital manufacturing neighbourhood. The rents were affordable. The artists needed a platform from which to become known in the art world; the dealers knew their profit margin would increase the faster their clients advanced from unknown to successful artists. Both profited from the arrangement. In addition, artists' cooperatives and alternative sites funded by patrons gave ambitious artists an opportunity to attract attention and prove their talent outside the commercial gallery scene. Leo Castelli, Ileana Sonnabend, Ivan Karp and Richard Bellamy, who ran small galleries, supported Pop no less than the artists themselves or the first receptive critics and museum curators, such as Alloway, G.R. Swenson, Lucy Lippard, John Coplans, Geldzahler or Walter Hopps.

In the capitalist U.S., success was no stigma — it meant public recognition, even fame, even though this tended not to be openly admitted. Jasper Johns, whose work is generally associated with Pop, was once moved by a derogatory remark Willem de Kooning made about his dealer, Castelli, to cast two beer cans in bronze, carefully paint labels on them, and place them on a pedestal. De Kooning had maintained that Castelli could sell anything as art, even beer cans. And as Johns amusedly remembered, de Kooning was right.

Castelli had shown Johns as early as 1954. The artist concerned himself with the thorny problem of what works of art really are, and invented paintings that appeared to convey contradictory meanings. Johns selected very special motifs: flags, targets, numbers. The flag and target paintings raised the issue of identity. What did they mean? Were they flags, targets, numerals, or simply value-free works of art? Should the viewer put his hand over his heart in face of a painting of an American flag, or shoot a gun at a target, or simply derive an aesthetic experience from these things? Johns subtly challenged the claim of modern art to radical autonomy, the ideological premise of the avant-garde, and illustrated its fundamental hollowness in face of the flux of changing meanings associated with even the most common things. As he realized, such meanings take on continually new nu-

1967 — Che Guevara is shot by Bolivian troops

1967 — Land Art is inaugurated in the USA

1967 — Italy sees the emergence of Arte Povera

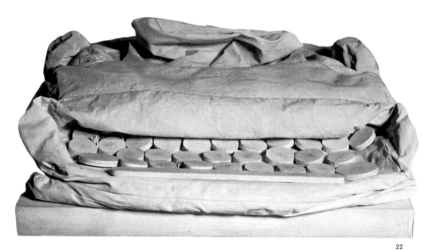

22. CLAES OLDENBURG

<u>Soft Typewriter</u>
1963, Liquitex on canvas over kapok filling and
a wooden structure, wooden parts fastened with
cords, 23 x 66 x 70 cm
Private collection

23. JAMES ROSENQUIST

<u>F 111</u>
1964–1965, Oil on canvas, 305 x 2621 cm
New York, The Museum of Modern Art, Mr. and
Mrs. Alex L. Hillman and Lillie P. Bliss Bequest

ances depending on the point of view from which objects are seen and the interests projected into them. In formal terms, Johns cooled down the explosive gestural language of Abstract Expressionism, yet still put great store in masterfully painted finish and individual touch.

"I'm not a Pop artist!" declared Johns, and in fact almost nothing connected him with Pop – apart from the fact that he infringed on the criteria of avant-garde art by opening the aesthetic inner sanctum to the general viewer and included the phenomenon of the effect of art works in his approach. He took the faithful depiction of objects so far that it approached sheer imitation, only the sensitive painterly treatment of the motifs representing the difference. This is why, whether he liked it or not, Johns paved the way for Pop.

While Johns kept the option between art and reality open, Robert Rauschenberg plastered his mostly huge-format paintings with all manner of things from the mundane world and charged them with reality. Reproductions of newspaper articles, press photos and pin-ups, street signs, letters, wire, wood, grass, even stuffed chickens and goats populated his painting surfaces. Heterogeneous found objects were embedded in gesturally painted passages, and what might have been a disorganized jumble was coerced into a disparate aesthetic unity. Yet the selected actual materials did not entirely fuse with the art. Fields of tension developed between the territories of the artistic and the real. Rauschenberg treated both on a basis of equality, and as a result, the aesthetic factor took on the character of the real.

In a certain sense he also raised the question as to the identity of the painted image, seeing as many of the real things he employed were products of mass culture. Rauschenberg used both traditional painting techniques and contemporary artistic processes. The method of transferring printed illustrations onto canvas – decalcomania – was borrowed from the Surrealist Max Ernst, and Rauschenberg, like Warhol, employed the commercial technique of silkscreen, or serigraphy, to reproduce photographic imagery.

Although they did not jettison the postulate of artistic subjectivity, Johns and Rauschenberg lent the sphere of the real more weight in their works than the British Pop artists did. In view of the Americans' paintings, Max Imdahl rightly diagnosed symptoms of an "identity crisis". Shaping reality was something with which these artists were familiar anyway. They had decorated display windows for the upscale department store Bonwit Teller on Fifth Avenue, and had participated in Allan Kaprow's legendary happening *Eighteen Happenings in Six Parts* in 1959.

A mixture of theatrical actions with elements of the dance and an informal dramaturgy, unconventional modes of artistic depiction and everyday behaviour, happenings were aesthetic attempts to escape from the self-chosen isolation of the avant-garde. Allan Kaprow in the U. S., Jean-Jacques Lebel and Wolf Vostell in Europe, developed the happening into a highly provocative form of art – and into an opposite pole to popular culture. "Art is life" was their battle cry.

1967 — During a demonstration protesting the visit of the Shah of Iran in West Berlin, the student Benno Ohnesorg is shot and killed by police
1967 — First human heart transplantation, by South African surgeon Christaan Barnard

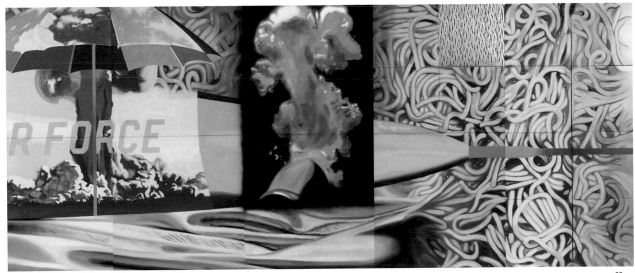

Downtown Manhattan, a vital milieu abounding in talents and eccentrics, was the site of the first group and solo exhibitions of Lichtenstein & Co. The artists knew each other through common projects, friends or goals. Oldenburg, like Dine and Lichtenstein, got on extremely well with Kaprow, for all of them had launched happenings. Rosenquist had gone to school with Oldenburg and Robert Indiana, and took drawing instruction during his postgraduate studies before becoming a prolific billboard painter. Wesselmann, after abandoning attempts in Abstract Expressionism, launched into collages with set-pieces from reality, and Warhol charmed clients and audiences with his shoe designs. Despite their intensive training as fine artists, they were all more deeply rooted in commercial culture than Johns or Rauschenberg, Kaprow or the British Pop artists. Their studios had not been limited to art, nor did they immediately succeed in making their mark on the art scene. They had to first detour through various fields of popular culture. Cinema, design and advertising belonged to their cultural environment like hamburgers and Coke.

So it is not surprising that after their initial halting attempts in an Abstract Expressionist vein, these artists began to search for aesthetically unexploited and visually powerful forms of imagery, and found them in the broad visual repertoire of mass culture. After all, they were experts in the field. Up to that point artists had merely quoted, usually ironically, this incredibly powerful imagery in their works, aesthetically transformed it or alienated it in collages or montages. The artists just listed, in contrast, appropriated this effervescent idiom almost unchanged, merely adapting specific characteristics to their artistic needs and intentions. They were not satisfied with simply transferring comics, food brands, design, photography, film and its personnel into the context of art, a la Duchamp. Instead, they as it were aesthetically improved the products of popular culture and lent them a permanent, if precarious, value.

Pop artists divided up the range of visual popular culture among themselves, and as soon as they had staked their claim to a certain segment, they began to subject it to variation after variation. Lichtenstein voted for the visual schemata of cartoons. Warhol abandoned comics as soon as he saw Lichtenstein's pictures, turning instead to the compelling emblems on soup cans, detergent boxes and soft-drink bottles, then progressing to photographic reproductions of movie stars, car and airplane crashes, electric chairs, mafiosi and world-famous works of art. Oldenburg produced home appliances and foodstuffs – in unusual materials and on unusually large scales. Wesselmann perfected advertising design, and Rosenquist painted irritating billboard-like images in modish colours of jet fighters, Volkswagens, women's legs and Ford cars garnished with spaghetti in tomato sauce. After rapidly staking their claims, these artists proceeded to shape their prefabricated vocabulary into individual brands that might superficially be described as styles.

1968 — Martin Luther King assassinated in Memphis, Tennessee

1968 — "Prague Spring" is suppressed by Russian tanks

24

A further point of agreement consisted of an impersonal artistic treatment of visual motifs and a cultivation of the smooth, perfect paint application of professional commissioned work. The resulting paintings provided no insight into their makers' mood, mental state, thinking, feelings or aspirations. No one would maintain that Lichtenstein was obsessed with comics, or Warhol with artless photographs. Although most Pop artists favoured hand craftsmanship (only Warhol adopting a technical process), their paintings could just as well have been executed by trained assistants working to their instructions. Assistants indeed began doing the basic work in their studios after the art market had accepted their works and they had attracted the attention of collectors like the taxi entrepreneur Robert Scull (whose Pop collection would be acquired by the German manufacturer Karl Ströher), the architect Philip Johnson, and the publisher Harry Abrams.

Lichtenstein condensed the narrative line of cartoons and its rapid progression from frame to frame into a single, characteristic image, or, more rarely, a double or triple one. He unified the image, honed it to a point. In his vision of comic imagery, Lichtenstein expressed what the photographer Henri Cartier-Bresson called the "decisive moment". The formulaic visual language of his patterns – which were never taken from recent comic books, but already had a certain patina – permitted Lichtenstein to evoke effusive feelings such as fear and horror, love and hate, without drifting into cloying sentimentality. An ironic overtone frequently reverberated in his pictures, especially when Lichtenstein translated outstanding paintings of classical modernism into the terms of his semiotic and chromatic system. "If a commercial advertising firm had a mind to really knock the public out for a hard sell, they might use one of Wesselmann's paintings", said Jill Johnston, a pre-Pop artist of the day, aptly pointing out the narrowness of the gap between commercial and supposedly non-commercial art. Wesselmann, who created Pop icons with his series of *Great American Nudes*, explained, "I use a billboard picture because it is a real, special representation of something, not because it is from a billboard." What might appear puerile and tasteless when seen on a street, takes on an unexpected freshness when encountered in an art gallery or museum.

Rosenquist, too, had no fear of sullying himself by contact with commercial art. He executed his compositions using the same methods he had learned as a billboard painter. His decision to expand the painting area to dimensions that viewers could not take in at a glance likewise went back to sophisticated advertising strategies. The artificial world of Rosenquist's art excluded all ordinary reality, including that of nature, and replaced it by the artificial reality of popular culture, fascinating and threatening in one. In his compositions an F 111 jet fighter plane extends across twenty-six metres of spectacular painting, a gigantic tank appears on diaphanous packaging foil, and a VW Beetle mutates into a horrifying insect.

1968 — Violent student uprisings in Germany, France, Belgium, Japan, Mexico, Yugoslavia and Poland; in Berlin, student leader Rudi Dutschke is killed

24. TOM WESSELMANN

<u>Landscape No. 2</u>
1964, Photograph, oil-paint and plastic on canvas,
193 x 239 cm
Cologne, Museum Ludwig

25. SIGMAR POLKE

<u>Freundinnen (Girlfriends)</u>
1965, Oil on canvas, 150 x 190 cm
Private collection

25

Oldenburg maintained the greatest distance to the culture in- dustry. His art was shot through with fine irony and a covert love of an- archy. Oldenburg reproduced mass-produced consumer articles in pa- pier maché and other absurd materials, rendering them useless for any meaningful purpose, or blew them up to such a monstrous scale that they exploded the familiar context and seemed to rock the foun- dations of civilization itself. Only in the commercial cinema of an Al- fred Hitchcock does the insurrection of objects take on a similarly frightening aspect.

The Pop artist par excellence is doubtless Andy Warhol. He rep- resented Pop not only in his art, but in his own person. Everything that made Pop revolutionary was contained in his work. And he rightly re- jected the assertion that Pop was a "counter-revolution". He linked up with artistic ideas that involved neither exaggerated individualism nor reflection on aesthetic models. In modern mass media and their tech- nical possibilities he discovered an artistic potential suited to modern mass society.

Warhol transferred their techniques, materials and forms, with slight retouchings, into the aesthetic field of art. By so doing, Warhol intensified the "identity crisis" of painting, which Johns had triggered with his flag and target paintings, into an identity crisis of modern art per se. His posthumous pictures of the movie star Marilyn Monroe — were they painted portraits or mythical icons? As icons, they would vi- sually embody the absent actress, would represent a piece of mythical

reality, and thus would not be art in the modernist sense of the term. After all, it was Warhol's *Marilyn* series that spirited the star into the realm of myth.

Warhol's art undermined the remaining bastions of art as art and used the popular media to breach its walls. Little by little, photo- graphy and film advanced into the galleries and museums, inter- national exhibitions and collections. And in their wake followed fashion, event culture, pop music. Warhol's Pop threw open the doors, and ever since, not only has popular culture been a theme of art but vice versa, art has become an integral part of popular culture. In hindsight, Alloway's reservations appear short-sighted.

In a "Factory" established for the purpose, the indefatigable Warhol oversaw a production of paintings on a division-of-labour, as- sembly-line basis. The process was half mechanical, half manual, em- ploying the silkscreen technique, which had become a favourite of commercial artists after World War II. That the execution was inten- tionally sloppy represented a concession to aesthetic reservations re- garding the perfection of popular mass-produced imagery. The sub- jects of Warhol's paintings and objects stemmed from the realm of consumerism and glossy magazines. By repeating the same motifs over and over again in endless series, he reflected the standardization of industrial mass-production. On the other hand, incessant repetition was a time-tested means used by the cultural industry to inculcate the significance of spectacular events.

1968 — Stanley Kubrick makes the film 2001 – A Space Odyssey
1969 — Nobel Prize for Literature goes to Samuel Beckett

1968 — Death of Marcel Duchamp
1969 — Rock festival in Woodstock

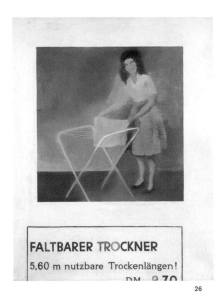

FALTBARER TROCKNER

5,60 m nutzbare Trockenlängen!

DM 8.70

26

26. GERHARD RICHTER
Faltbarer Trockner (Collapsible Clothes-horse)
1962, Oil on canvas, 105 x 70 cm
Private collection

The camera accompanied Warhol wherever he went. Not coincidentally, his photos mark a key stage in the history of photography. Moreover, as director and producer of documentary and feature films, he catapulted himself into cinema history. Warhol was not only the "cool" producer and observer; he was a virtuoso player on the keyboard of the cultural enterprise and consciously exploited its laws for his own purposes. With his canny and slightly subversive activity, Warhol put an end to the fiction according to which a non-commercial approach was an infallible sign of extraordinary art. "Noncommercial art has given us Seurat's 'Grande Jatte' and Shakespeare's sonnets, but also much that is esoteric to the point of incommunicability. Conversely, commercial art has given us much that is vulgar or snobbish (two aspects of the same thing) to the point of loathsomeness, but also Dürer's prints and Shakespeare's plays."[8] And the images of Pop Art, photography, motion pictures …

Notes
1 Lawrence Alloway, "The Development of British Pop", in Lucy R. Lippard, *Pop Art* (1966), 1970, p. 27.
2 Ibid.
3 Ibid., p. 9.
4 Peter Selz, quoted in Anna Umland, "Pop Art and the Museum of Modern Art: An Ongoing Affair", in *Pop Art – Selections from The Museum of Modern Art,* exh. cat., The Museum of Modern Art in collaboration with the High Museum of Art, ed. by Harriet Schoenholz Bee, New York, 1988, p. 13.
5 Clement Greenberg, "Avant-Garde and Kitsch" (1939), in *Pollock and After,* ed. by Francis Frascina, London, 1985.
6 Henry Geldzahler, "Hockney: Young and Older", in *David Hockney. A Retrospective,* exh. cat., Los Angeles County Museum of Art, Metropolitan Museum of Art, Tate Gallery, organized by Maurice Tuchman and Stephanie Barron, Los Angeles, 1988, p. 19.
7 René König, *Soziologische Orientierungen, Vorträge und Aufsätze,* Cologne and Berlin, 1965, p. 544.
8 Erwin Panofsky, "Style and Medium in the Motion Pictures", in *Three Essays on Style,* ed. by Irving Lavin, MIT Press, Cambridge, Mass. and London, 1995, p. 119. This essay was first published in 1936!

1969 — Franco-British supersonic passenger plane, the Concorde, makes first test flights

27. JEFF KOONS

<u>Michael Jackson and Bubbles</u>
1988, Ceramics, 107 x 180 x 83 cm
San Francisco, San Francisco Museum of Modern
Art, Purchased through the Marian and Bernard
Messenger Fund and restricted funds

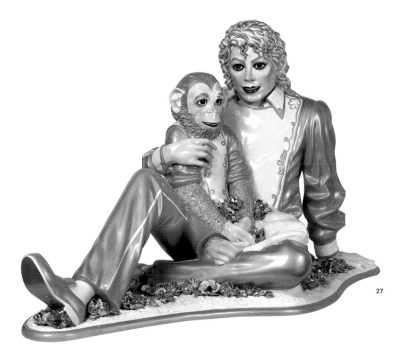

27

1969 — July 21: The U.S. beat the U.S.S.R. to the moon, when Neil Armstrong becomes first man to set foot on its surface

27

on the Balcony

Oil on canvas, 121 x 91 cm
London, Tate Gallery

Long before contemporary art legitimated the collecting of curios under the name of "clue-finding" or "forensic art", Peter Blake showed himself to be a collector, or at least a painstaking registrar. He presented his collection not in the form of original finds but in painted form, as here, where they are brought together frontally on a green ground. The objects of Blake's collection share the picture with four young people, lined up in pairs on a bench. Also depicted is an angular table, on which stands another girl, only the lower half of whose figure is visible. The character of the things depicted might best be described by the term "miscellaneous". Two-dimensional objects like paintings and drawings of diverse origin – but none over one hundred years old – are in the majority. These are accompanied by covers from the illustrated magazines *Life* and *Weekly Illustrated,* a photograph of Sir Winston Churchill complete with waving royal family, an earlier panorama picture of the royal family with European relatives, a packet of cigarettes, an open book, a third photograph, and a pennant. On the table at the left sit ordinary consumer goods such as a package of margarine, a half-full bottle of pop, a tin of sardines, a newspaper … The list is by no means exhaustive. Probably the artist merely "registered" whatever had happened to accumulate in his studio. Every motif is painstakingly rendered, down to the tiniest detail, with photographic fidelity. Their plasticity contrasts strangely with the schematically depicted, relatively childish faces and figures of the young people. Nothing in the collection seems extraordinary – were it not for the masterpiece by Edouard Manet that crops up almost unnoticed at the left edge and that gave Blake's picture its title: *The Balcony,* 1868. The artist has placed this superb work of art on the same level as the trivia of mass culture. In fact, in this context it becomes an integral part of this culture. For as its small dimensions indicate, the Manet is merely a copy or reproduction in a gilded frame. Although the relationships among the diverse objects remain enigmatic, Blake's painting subliminally raises the issue of the status of the work of art in the age of its technical reproducibility (the subject of a groundbreaking essay by Walter Benjamin), and quite casually demonstrates the change that has taken place in our habits of perception since the French artist's day, the consequences of distracted vision.

**b. 1932 in Dartford, Kent,
Great Britain**

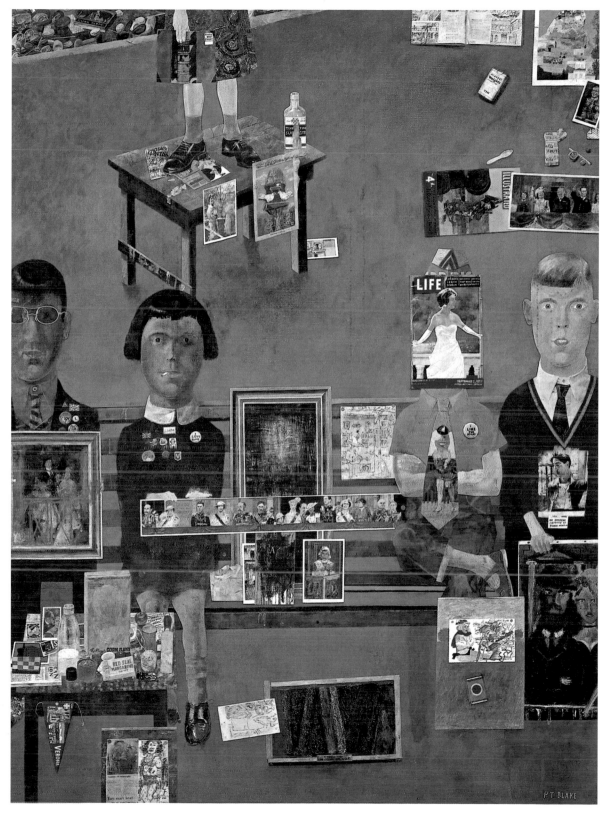

u. s. Highway 1, number 5

Synthetic polymer on canvas, 177.6 x 207 cm
New York, The Museum of Modern Art, Gift of Mr. and Mrs. Herbert Fischbach

With the exception of meteorite hits from outer space and the long ice ages with their geological displacements, nothing has changed the face of our planet more than the automobile. Neither industry nor the railroad nor the aeroplane. And unlike the railroad and the aeroplane, the automobile is more than just an essential factor in modern civilization and a key motor of economic growth. It is also a symbol of individual freedom – the freedom to move without physical exertion wherever and whenever we like. Yet to do so, a dense network of streets and roads through cities and countryside is required. Private cars mobilize the masses, and as a result, cities burgeon into endless unwieldy megalopolises, beset by an incessant flow of traffic in and out, resulting in the inevitable jams. An independent culture has grown up around the automobile, complete with its own sign system and behavioural code: traffic culture. Allan D'Arcangelo, a painter whose relationship to Pop vacillates, has made a psychological aspect of this culture the subject matter of his art, and graphically developed it in extended series of works. In his large-format paintings, the experience of the landscape from the point of view of a speeding motorist becomes a visual event. The geological, topographical and cultural differences between the stretches of countryside the car rushes through are reduced to a few fleeting, cursorily depicted details: the endless ribbon of road, the changing light, emblems from the repertoire of traffic signage, and the sky over a far horizon. Accordingly, the painter reduces perception of the landscape to elemental forms and a few highly contrasting colours, to the data registered by the motorist's eye. D'Arcangelo is the sole Pop artist to have relinquished the role of detached observer. The composition of *U. S. Highway 1, Number 5*, one of five versions in a series, is marked by an exaggerated perspective that literally pulls the viewer's eye into it and catapults it up to the upper edge, directly linking perception with physical sensation. It mobilizes the eye and draws it over the strongly foreshortened road from the anonymous foreground to the illuminated billboard and the numbering behind it. The painting surface suddenly metamorphoses into a virtual movie screen, on which the image seems to be in motion. An image as if taken by a camera moving precipitously forward. The smooth paint application and constructed composition stand in contrast to the picture's emotional effect. Not even the evocation of the twilight hour awakens romantic feelings. The picture as such, at any rate, is a symbol of the unlimited possibilities of the American Dream, as invoked in countless literary works, photographs and above all, in the movies.

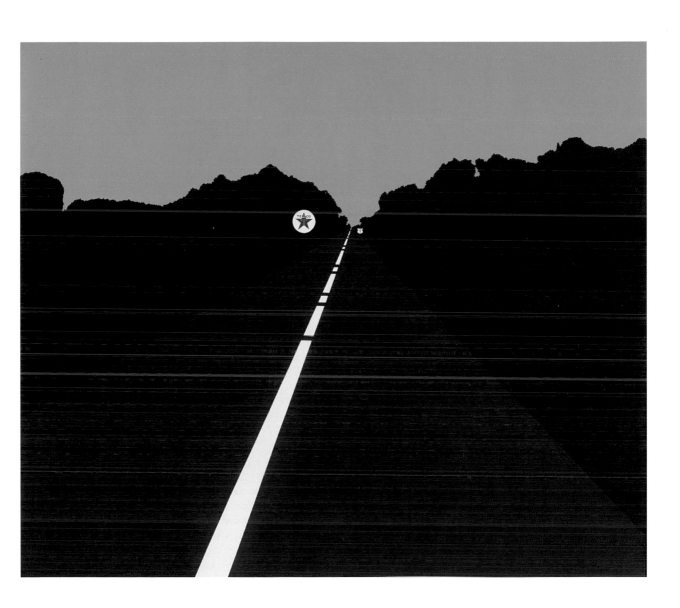

road series NO. 13

Oil on canvas, 200 x 253 cm
Cologne, Museum Ludwig

b. 1930 in Buffalo, New York, USA
d. 1998 in New York, USA

The white stripes in the black band at the lower edge of the painting diminish step by step to a vanishing point. At the same time, they form an acute triangle on whose point most of the rest of the painting seems to pivot. Composition and structure suggest an abstraction, yet the title indicates the presence of a recognizable subject. As a result, we perceive the black band to represent a road, the stripes a pedestrian crossing, the large, toxic green area a field, the six regularly spaced lozenges police barriers, and the light blue band at the top, as broad as the black below, to represent the sky. In view of the proportions of these things in reality, however, this interpretation causes problems. Although the perspective lines of the white stripes draw our eye into the distance like a hurrying pedestrian, it is only to run up against what appears to be an insuperable green wall. Only the geometric red shapes in the upper third of the painting seem capable of penetrating this wall, thanks to the complimentary red-green contrast. We cannot be sure what is background and what foreground, because they continually change places in optical perception. This play is repeated throughout the picture, as an artistic principle. Just as our perception continually oscillates between space and plane, the composition oscillates between abstraction and rudimentary realism. Rather than either-or, the principle at work here is both-and. D'Arcangelo seems closer to Ellsworth Kelly and Hard Edge Painting than to Lichtenstein and Warhol. In addition, he employs means typical of Op Art. Thanks to a masterful and sparing use of various painterly means, his work has the effect of virtually pulling the ground from under the viewer's feet. Like certain scenes in Alfred Hitchcock's films, when a camera simultaneously trollies forward and the zoom pulls back. In fact, the artist's inspiration came not only from art and actual experience, but in large part from the cinema. As a result, D'Arcangelo takes his place in the great tradition of American landscape painting, but with the eye of a modern motorist. Later he would turn his attention to the visual inventory of air travel.

Double Isometric self-Portrait (serape)

Oil, wood and metal on canvas, 145 x 215 cm
New York, Whitney Museum of American Art, Gift of Helen W. Benjamin

==

Although his paintings – more precisely, his painting-objects – have been and still are represented in every important exhibition of Pop Art, Dine has never concealed his scepticism with regard to its significance. Superficially, there would seem to be little difference between his works, especially the earlier ones, and those of Lichtenstein, Warhol, et al. A preference for the everyday and mundane is found in Dine as well, as is a distance from Abstract Expressionism. No less obvious, however, is the artist's inner detachment from popular culture. Still, articles of clothing did play a key role in Dine's work during the emergence of Pop. Trousers, jackets, coats in many variants populated his canvases, and not seldom these functioned as mere backgrounds for the real articles, hung in front of them.

Double Isometric Self-Portrait (Serape) is a double image of a schematically rendered robe. At least on first glance. Soon we realize that these must be two robes, if extraordinarily similar in terms of outline, form and length. That the depictions resemble sewing patterns is no accident, and it would be more correct to describe them as reproductions of patterns for articles of slightly different sizes. Especially as they are composed of a series of separate elements, like collages. This impression is further underscored by the diverse colouring. And just as the artist has built up the robes' form of precisely contoured irregular colour fields, he has structured the two wings of the picture like a mosaic of diversely coloured shapes. As a result, on longer scrutiny the distinction between figure and ground begins to blur, the contours of the robes dissolve into abstract formal puzzles. In front of these dangle chains, one in each half. At the lower edge, the chains end in a ring with a section of wooden dowel.

The world of things in Dine's works is pervaded by personal references and allusions. The articles of clothing are like a second skin to the artist, a second self. On the other hand, in a happening he staged before beginning his painting career, Dine used his own skin as a basis for painting. Still, the artist is concerned most with elementary artistic problems, foremost issues of visual perception, the tension between signified and signifier, simulated and factual.

b. 1935 in Cincinnati, Ohio, USA

Hollywood (Jean Harlow)

Acrylic on wood, 78 x 89 x 31 cm

Washington, D. C., Hirshhorn Museum and Sculpture Garden, Smithsonian Institution, Gift of Joseph H. Hirshhorn

If Ruscha illuminated the Hollywood myth in the form of magical letters and Warhol celebrated it in the form of great divas, Grooms materialized the fleeting glamour of the Dream Factory in three-dimensional plastic shape. Wood and acrylic paint are the stuff of which myths are made. In front of a fanlike semicircle, like Aphrodite receiving one of her numerous suitors, a goddess of the silver screen who died at an early age reclines on a divan with pleated coverlet, beaming with wide eyes and tempting smile at her audience, who stand in for her lover. Everything, every gesture, facial expression, appeal is addressed, as in the movies, not to her fellow actors but solely to her public. With the difference that Grooms, unlike the illusion machine that is cinema, does not hide this circumstance but accentuates it. Her pretty legs raised and bared to over the knee, the platinum blonde Harlow accords us a glance into her magnificent décolleté by lifting her arms to her head. She dominates the scene in the sculpture as she frequently did in her films, despite the fact that a male partner in a black tuxedo sits on the edge of the bed, worshipping her. This is not Clark Gable, into whose arms she fell most often, but probably Franchot Tone, whom Grooms did not find worthy of mentioning by name.

Harlow, who died prematurely in mysterious circumstances, was more than a prototype for the pin-ups Lana Turner and Marilyn Monroe, with whom she had much in common. Yet despite her unusually erotic screen presence and comic talent, she has long descended into the shadow realm of cinema, and even in Grooms' sculpture, she figures as little more than a metaphor for a culture industry that transforms mere shades into deceptive heroines and heroes. In addition to advertising, comics and glossy magazine photos, Hollywood provided much material for the stockpile of Pop imagery. Grooms, however, was no typical Pop artist. Although he had exhibited with Dine, Lichtenstein, Oldenburg and Segal in downtown Manhattan (at the Reuben Gallery) and participated in happenings, unlike them he practised an outspoken social critique, usually with a satirically exaggerated touch.

Harlow's smile in *Hollywood* turns into a distorted grimace, and her obtrusive appeal to the audience only conceals the abysmal loneliness of a former sex symbol, as well as the fact that in the eyes of the culture industry, she was little more than a vehicle for earning money.

b. 1937 in Nashville, Tennessee, USA

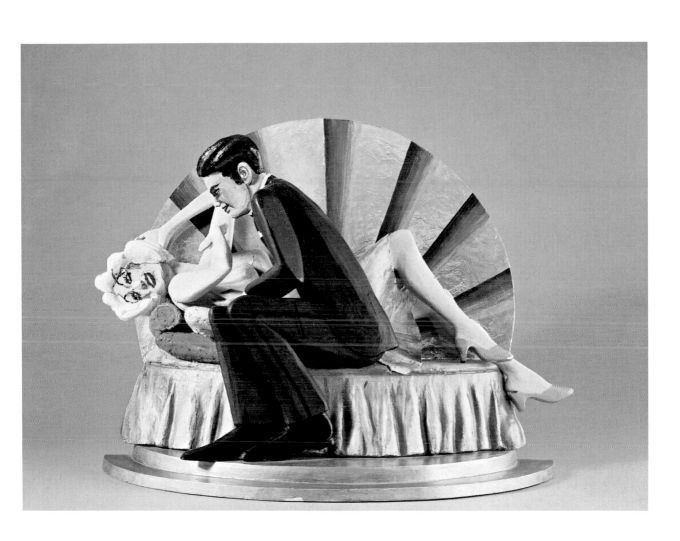

my marilyn (paste up)

Photos and oil on canvas, 50 x 61 cm
Cologne, Museum Ludwig

Two years after her death, Richard Hamilton created his personal image of Hollywood star Marilyn Monroe in this "paste up", a term used by commercial artists to describe a layout ready for reproduction and printing. This is no homage to the actress who was a great star in the cinematic sky but had not yet reached the mythical status which Warhol helped her achieve. Hamilton's image is more like a brief, graphic analysis of the mechanisms to which she owed her fame. Twelve photos of Monroe are arranged on the canvas, their frames identifying them as contact prints from a photo session on the beach. With few exceptions, Hamilton has coloured or tinted them. The formats of the altered contacts vary, only the last one diverging, and not in terms of size alone. Against a sky divided into purple and orange fields, we see a white fleck instead of a person, only the contours of the figure remaining, like an empty stencil. In the series of shots arranged in two blocks of four, the artist has apparently conducted something in the nature of a successive expungement of a human personality, or the transformation of an individual into an object of consumption. Marilyn Monroe had evidently posed in a bikini for an unnamed photographer, while performing her usual antics. Hamilton used the results for his collage. The best pictures from the session were intended for publication, that is, were not private snapshots. This is indicated by the crosses on the many photos which did not pass muster. One bears the remark "good". It shows the star in her most marketable pose: happily laughing, taken from the slightly raised vantage point of the "American view", that is, revealing deep insight into the top of her bathing suit. *My Marilyn,* of which an earlier, less radical version exists, mercilessly illustrates by the simplest means the price someone from the pin-up school had to pay to become a Hollywood star. In her last interview, published by Enno Patalas, Marilyn confessed that the worst part of being a sex symbol was that it made you into a thing. And she simply hated being a thing. Hamilton is an unusual artist. Before studying painting at various schools, he devoted himself to a career in commercial design and advertising. As a teacher and co-organizer of groundbreaking exhibitions he figured, alongside Eduardo Paolozzi, as a key figure in British Pop Art, and was a member of the creative Independent Group at the ICA. He became a confidant and friend of Marcel Duchamp, who, with James Joyce, exerted a great influence on him when Hamilton concerned himself intensively with Duchamp's work, including the making of a reconstruction of his masterpiece, *Le Grand Verre* (The Large Glass, 1915–23). Hamilton belongs to that exclusive group of artists for artists, who have had a much greater influence on the art of modernism than their sparing presence in the world's museums would suggest. Hamilton himself, by the way, considers himself an "artist in the old style".

b. 1922 in London, Great Britain

Just what is it that makes today's homes so different, so appealing?

Collage, 26 x 25 cm
Tübingen, Kunsthalle Tübingen

When the critical literature cites one picture as having announced the advent of Pop Art, it is referring to Richard Hamilton's collage with the tricky question, *Just what is it that makes today's homes so different, so appealing?* On the lollipop wrapping being toted for some inscrutable reason by the muscle builder at the left stands the word POP, in yellow on red. For many people, this collage of cut-out magazine illustrations represents the primary source of the term. Other commentators go so far as to state that every connection between Pop and popular culture was a matter of chance, accidental. Pop, like Dada, was a spontaneous coinage, they say, and cite the British artist's work as proof. What speaks against this argument is the fact that the collage was not originally conceived as an independent work of art, but rather as an illustration for the catalogue to an exhibition with the fine title, *This is Tomorrow,* held in 1956 at the Whitechapel Art Gallery. Although the show concerned itself with issues of everyday culture, primarily from the point of view of architects and city planners, it was not without influence on the development of Pop Art in Britain, because it looked beyond the confines of fine art to modern urban civilization and its forms of visual expression. Hamilton was one of the designers involved in the presentation, which caused a furore especially because of its "fun-fair architecture". Yet more importantly, the insignia of popular culture had suddenly cropped up in a bona fide art gallery which, like all art galleries, had previously considered itself a bastion against the "visual trash" purveyed by the commercial media. Hamilton's innuendo-filled collage presents some of the key building-blocks of this industrially produced popular culture: sexy, artificially modified human physiques both male and female; contemporary video and audio technologies; and the clinically clean atmosphere of the modern household, complete with its impersonal furnishings. And the composition contains a nearly complete anthology of modern visual media: poster, company emblem, cinema – visible behind the body builder is an ad for what is thought to be the world's first sound movie, *The Jazz Singer* – and television. Not to forget the handicraft of collage, a paste-up of various set pieces from the illustrated press, a technique and form used by the artist to reflect on the nature of the medium itself. Every element from which Pop Art would later grow is present, including a critical undertone. Doubtless this collage stands at the beginning of an artistic revolution, but it does not embody it, merely having served to supply it with motifs. Yet this holds, if at all, only for the British version of Pop, not the American.

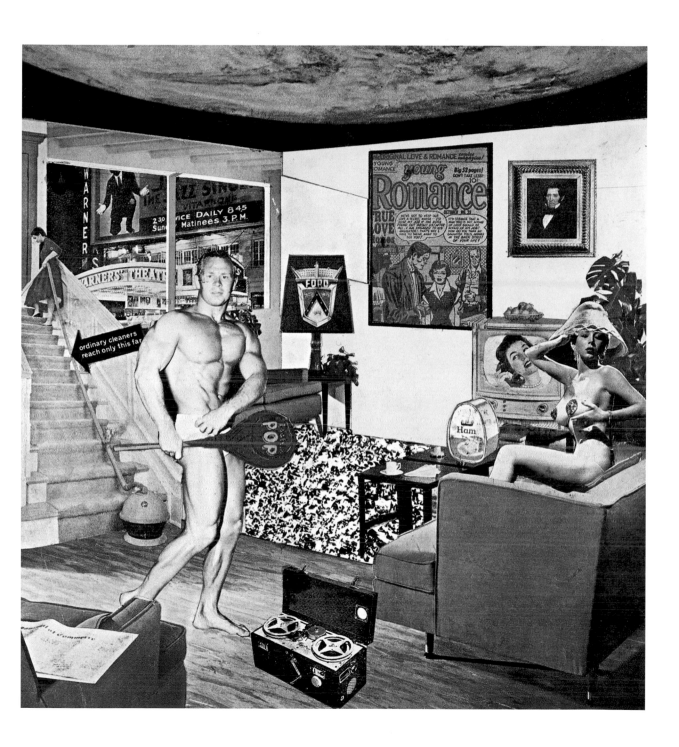

Tea Painting in an Illusionistic style

Oil on canvas, 198 x 76 cm
London, Tate Gallery

The outside contours of this oil painting correspond to a two-dimensional depiction of an open tea box, viewed from above. Yet the shape of the open lid already diverges from the laws of perspective. This form runs counter to the rules of illusionistic representation that govern traditional painting, forcing the upper section of the picture into the actual plane of the canvas. The same is true of the painting approach itself. Although a few details of the label are identifiable and the "image" of the package is conveyed, the arrangement of the lettering and the paint application reveal a certain subjectivity, a carelessness and spontaneity that cannot be explained by evanescent reflections like those in the upper part of the picture. But the seated nude male figure, extending beyond the outlines of the tea box, completely eludes the convention of the "illusionistic style" referred to in the title. This is literally a foreign body, the most disturbing one in the composition. Naturally the title claims just the opposite of what we see, and the apparent lack of mastery of traditional schemes of representation is only feigned.

Although *Tea Painting in an Illusionistic Style* partakes of the spirit of Pop, primarily in terms of motif, David Hockney is anything but a Pop artist. Neither is he interested in the realm of mass consumption and its brazen symbolism, nor is he fascinated by the phenomenon of the reproducibility of the work of art, including its standardized language. Hockney does receive impulses from popular culture, but he reshapes them to conform with his aesthetic ideas. The resulting imagery ultimately remains more beholding to his artistic world than to the reality from which its elements were derived. The apparently child-like drawing, the delicate use of colour, the traces of the painting hand, the suggestions of sexual desire are more important than the elaborately rendered box, despite the fact that tea is for the English what Coca Cola is for Americans.

The artist's later development illustrated his distance from Pop even more clearly. It was more strongly inspired by the Mediterranean spirit of Matisse and Bonnard, especially in terms of a celebration of light and regardless of choice of motif and palette, than by the spirit of cinema and advertising. And even when Hockney turned to photography, his concern was not so much with its character as a medium as with its specific pictorial qualities.

b. 1937 in Bradford, West Yorkshire, Great Britain

тhe Big Eight

Acrylic on canvas, 220 x 220 cm
Cologne, Museum Ludwig

Abstract? Figurative? Realistic? Art for art's sake? Somehow all of these questions bounce off this painting with a great, bright red figure eight on a blue ground in the centre. Certainly a number is an abstract symbol representing a certain amount. But here the digit does not indicate an amount, unless it be the circle composed of eight arc segments in white that surrounds it like a nimbus. The title naturally leaves no room for such speculation. It does not go beyond what the eye sees. "What you see is what you see", is the often-quoted maxim of the artist Frank Stella, a contemporary of Robert Indiana. Yet Stella made his mark with abstract, structuralist painting-objects, whereas Indiana is associated with Pop Art. So might the number refer to something beyond the painted canvas which the title conceals? In other works by this artist, numbers refer to the numbers of national highways, which in fact provided the initial inspiration for his concern with numbers. Yet nothing indicates the presence of this reference here. The number, given as a digit rather than being spelled out in letters, seems to represent pure form, as in Jasper Johns' early number paintings. Both artists raised standard numbers to the level of an artistic motif. While Johns qualified the intrinsic value of numbers by embedding them in a gesturally painted field, Indiana presents numbers straightforwardly, like insignia, in all of his paintings and sculptures. Still, the present work cannot be called an abstract painting – the number as an autonomous image, corresponding at most to the eight-part circle whose centre it occupies, with a tendency to three-dimensional emphasis typical of Indiana. Because in terms of form, colour and presentation, the composition has its source in the fund of popular culture. The "8" is a stereotype; the colours, applied in an apparently monochrome way, form a familiar red-blue contrast; and the fact that the "8" appears in a square stood on one corner calls up associations with highway signs. Indiana, who originally wrote poetry, builds a bridge between Pop Art and the Hard Edge Painting of an Ellsworth Kelly, without making facile compromises. At the same time, he ironically undermines art critics' obsession with classification. This is seen, for instance, in the fine bands in various gradations of blue that make up the seemingly monochrome ground. With his *Number* and *Love* paintings and sculptures, Indiana created true icons of Pop.

**b. 1928 in New Castle, Indiana, USA
as Robert Clark**

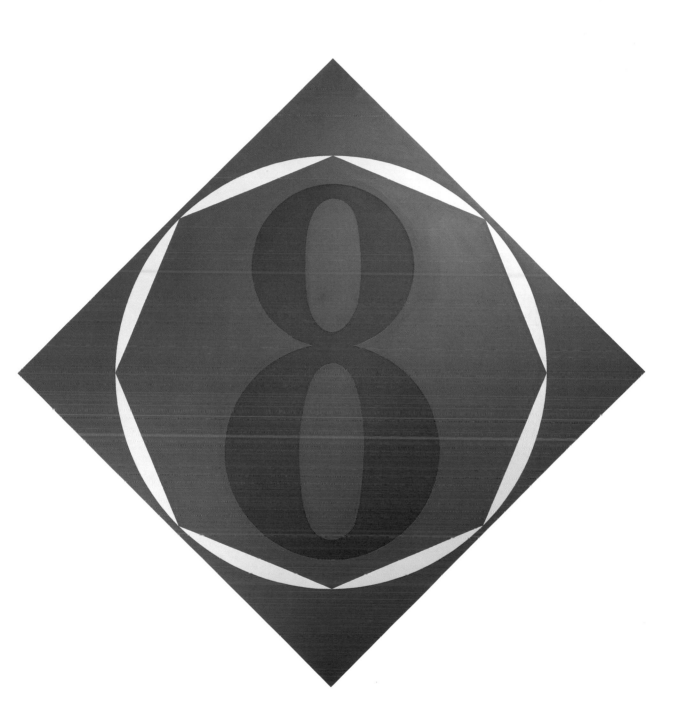

Flag

Encaustic, oil, collage on cloth, mounted on plywood, 108 x 154 cm
New York, The Museum of Modern Art, Gift of Philip Johnson in honour of Alfred H. Barr, jr.

The by now inevitable question as to the identity of this painting was not raised until ten years after its completion, when the critic Alan Solomon asked whether it was a flag or a painting that represented a flag. It is both, according to the artist's various answers to this question. On the surface, the work possesses many traits of the American star-spangled banner: appearance, the congruence of ground and motif, proportions. Then, too, the painting, in analogy to the flag, consists of three separate parts fitted together: a field with stars, and adjacent fields with red and white stripes to the right and below. In other words, it is a montage. Each star, as in the original, is a separate piece, adhered to the ground. What initially appears to signal an artistic context turns out to correspond to real circumstances. He dreamed of painting the "Stars and Stripes", the artist explained his baffling decision to treat this subject, and he wasted no time in putting the dream into practice. In fact, he did not depict a flag, but painted the flag. The flag is not the motif of the picture; the picture is a flag. On first view, the subject and painting surface are identical. From this we may conclude that Johns was right when he said that the theme of the painting was painting itself – painting in the physical sense, as brushstroke, colour, object. The encaustic technique employed is difficult to handle, because the medium, liquid wax, solidifies quickly and immediately fixes every gesture. Its traces remain visible. Johns began with enamel, but since the drying process lasted too long, he changed to encaustic. The translucent strokes reveal loosely collaged pieces of newspaper underneath. These shimmer through the painted surface and serve as the actual background for the flag's stripes. In light of a more precise analysis, various layers of meaning crystallize out of this painting with the laconic title *Flag*, that convey complex relationships between reality and art without any clear statement of position, in analogy to the American flag itself. Viewed soberly, the banner is nothing but a printed or dyed and hemmed piece of cloth. Yet in fact it is a symbol of national and social identity in the United States. When the artist executed this painting, the phenomenon of war influenced his view of the world. War in three variants: the Cold War between East and West, the U.S. and the U.S.S.R. competing for world dominance; the hot war in Korea, which had just come to an end; and Senator McCarthy's witchhunt on intellectuals, which was still underway and poisoning the American cultural climate. *Flag*, in many people's eyes a milestone on the road to Pop Art, was viewed by others as an attack on patriotic feelings.

b. 1930 in Augusta, Georgia, USA

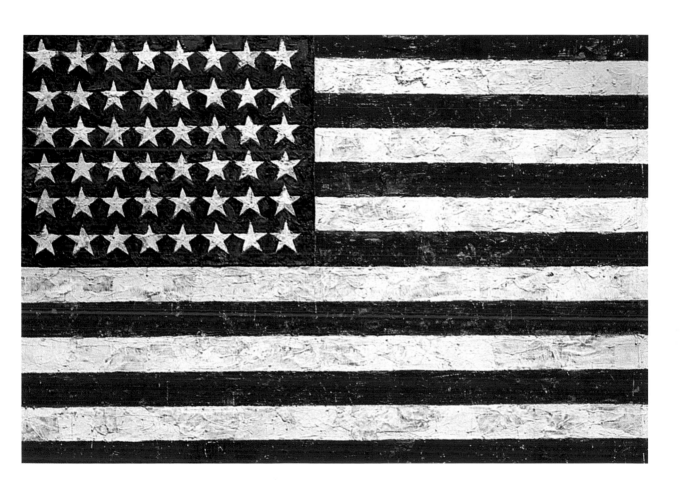

perfect match

Oil on canvas, three parts, 280 x 93 cm overall
Cologne, Museum Ludwig

Successful careers on Broadway are only a matter of "tits and arses", according to saucy song in the film musical *A Chorus Line*, 1985, by Sir Richard Attenborough, a reprise of an old, already filmed play with updated lyrics. Allen Jones long since knew this, and threw in slender shapely legs and a sensual mouth for good measure. In three superposed parts, a vertical triptych, he rendered the ideal female image that preoccupied men's minds in a period of social and cultural transition. At the same time, it is an image of covert anxieties. The figure's parts are so exaggerated to conform with personal tastes or neuroses that they can stand for themselves. Mouth and breasts in the upper field; hips, buttocks, pubic area and thighs in the middle; calves, ankles and feet in the lower field. The sharp, shaded contours underscore the cliché and focus it to the point of caricature. The head is cut off above the mouth by the edge of the picture, as if a woman's face were dispensable. A miniskirt reveals more than it conceals – just as in "real life". The legs are rendered in a Futurist manner, a subtle homage to Marcel Duchamp and his renowned *Nude Descending a Staircase*, 1912. Just as little nuanced as the drawing is the handling of colour. Red predominates. At the top, in a strong contrast with black, in the middle a bit cooler and balanced by blue-grey and yellow, and at the bottom the red explodes in a complementary contrast with toxic green, interspersed with yellow and orange. The palette is like a strident pop concert translated into visual terms. Doubtless Jones has created a modern fetish image here. Yet it conveys not the slightest insight into the thoughts and emotions that moved him. Any attempt at psychological interpretation is bound to miss the point of the painting. Jones stays as cool as Helmut Newton, whose photographs of women were concurrently triggering controversy. Jones' female image is the equivocal product of aesthetic design and commercial insignia. Entirely artificial, all the way to the erect nipples, just as shrill and vulgar as the magazines that were purveying the same image at the time. In the museum context, however, it still embodies an extreme challenge to the aristocratic female image of the classical art around it, a travesty that reveals what these works often conceal beneath a veil of painterly refinement. It was David Hockney who drew Jones' attention to the world of the mass media. In 1978 Jones would design an ad for a stocking manufacturer, which filled an entire wall of a railway station, Schweizer Bahnhof, in Basel. Here the influence of advertising on art was reflected back on advertising.

b. 1937 in Southampton,
Great Britain

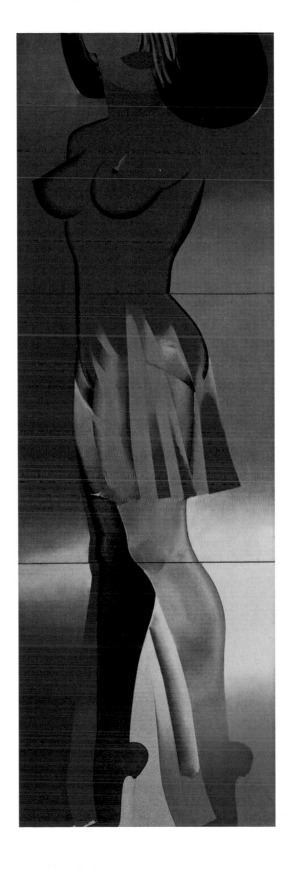

такка такка

Magna on canvas, 173 x 143 cm
Cologne, Museum Ludwig

Pablo Picasso's painting *Massacre in Korea* drew harsh criticism. Yet the many aesthetic arguments marshalled against it basically reflected a doubt as to the ability of painting in general to adequately depict the horrors of war. Hardly twenty years after Picasso's canvas *Guernica,* 1937, which was immediately accepted as an icon of critical art, photography had far outstripped painting as a medium to convey the effects of war. Roy Lichtenstein's *Takka Takka,* an outstanding Pop contribution to art history, proves how baseless such distinctions are. Precisely the coarsening effects of the cartoon idiom, in combination with elements of written language, lend the painting an overwhelming force and, at the same time, give it a disturbing ambivalence. The threatening muzzles of the barking machine gun in harsh black and white above the dark green jungle leaves, underscored by the echoic "TAKKA TAKKA" in blood red capitals and the shamelessly heroicizing text on a yellow ground in the upper third of the composition, convey a more unforgettable impression of the violence of war than all of the noncommital television images taken by cameramen "embedded" with troops in a real war thirty years after this painting was completed. And not only this – Lichtenstein's work provides insight into the role which images have played and will continue to play in war. The artist initially limits himself to showing guns at the moment they fulfil their purpose, as if automatically and only because this is what they are manufactured in great numbers to do. Neither a gunner nor his potential victim is visible. This considerably increases the aggressiveness of the image. There is no shallow psychology, no dubious human touch, to mitigate the challenge. The gunner is mentioned only in the cloyingly heroic texts, which sound as hollow as most justifications of violent acts and the commentaries of war reporters. Victims, on the other hand, do not fit into the picture of triumphant violence, and never have. By condensing aspects of artificiality – poster-like colour and formal systematization – to an extreme point, Lichtenstein creates room for an invasion of the real into the world of fiction, by way of the bridge of the imagination. By these means he conveys an idea of the consequences of an outbreak of brute violence, even though it takes shape primarily in the mind of the viewer – thanks to the sheer power of the medium.

**b. 1923 in New York,
d. 1997 in New York, USA**

THE EXHAUSTED SOLDIERS, SLEEP-
LESS FOR FIVE AND SIX DAYS AT A
TIME, ALWAYS HUNGRY FOR DECENT
CHOW, SUFFERING FROM THE TROPICAL
FUNGUS INFECTIONS, KEPT FIGHTING!

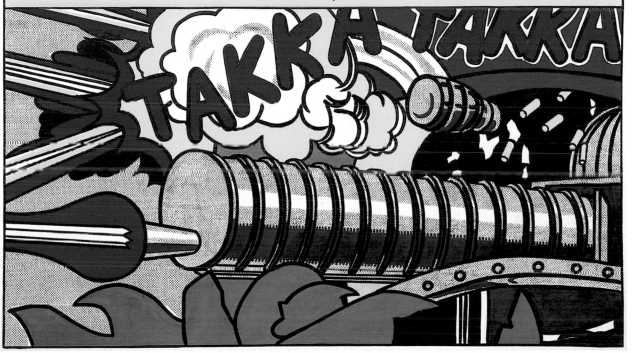

M-Maybe

Magna on canvas, 152 x 152 cm
Cologne, Museum Ludwig

==

What especially stimulated his interest in cartoons, the artist once said in an interview with critic, curator and photographer John Coplans, was the contrast between highly emotional content and "cool" means of depiction. Especially in the many paintings of young women done during the first half of the 1960s, Lichtenstein staged this contrast with amazing virtuosity, lending the compositions a vibrant tension. In *M-Maybe,* an attractive blonde directs her blue-eyed gaze at us, yet seems to look past us, preoccupied with her own thoughts. Head resting in her left, white-gloved hand – a traditional visual metaphor for melancholy – she wonders, as the balloon reveals, why she has been made to wait in vain. Apparently some man has stood her up. The everyday nature of this situation immediately triggers empathy on our part. It is certainly not hard to identify with this girl – were it not for the standardized way in which the artist depicts her. This puts the despondent girl at an undefinable, vague distance, in view of which our budding empathy turns out to be a special form of hypocrisy. The relationship between picture and viewer suddenly seems based on false premises. The artificiality of the style corresponds to the stereotyped female image derived from comic books. And also to the cheap sensations this image was designed to elicit in us, which suddenly put us in the role of Pavlov's dogs. The artist skilfully exploits the gap between the world and individual consciousness. He heightens comic-book clichés by honing his technique to an apex of forcefulness: primary colours, strong contrasts, and striking, unifying drawing. This amounts, so to speak, to an optimization of the popular aesthetic. Lichtenstein always emphasized that he aesthetically improved the vulgar aesthetic of cartoons. His first step in making a painting was to project the original on canvas with the aid of a slide projector, thus creating an analogy on the technical level between mechanical production and the world of trivial feelings. Then the face was covered with a dot pattern – a relic of the printed original, divested of its function to take on an aesthetic life of its own in the work of art.

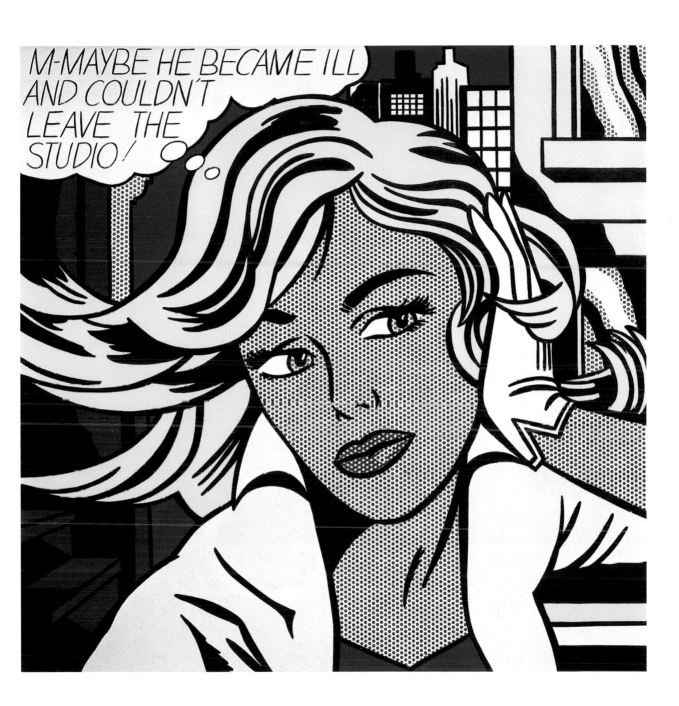

yellow and green вrushstrokes

Oil and magna on canvas, 214 x 458 cm
Frankfurt am Main, Museum für Moderne Kunst

Every type of painting consists of an abundance of brush-strokes. The way these are executed is not unimportant, since it determines the visual effect of the motifs to which they add up, whether these motifs be objective or abstract. In other words, the visual effect of a finished painting depends on the process used to make it. As art became more and more individual and artists' subjective vision began to appear just as, if not more, important for the aesthetic judgement than the depiction itself, the psychological aspect of brushstrokes was discovered, and they began to be read as notations of artists' states of mind during the creative process. Expressionist tendencies augmented this development, to the point that the gestural strokes in Abstract Expressionist paintings were thought by many to completely reveal their maker's psyche. In his series of *Brushstroke* paintings, Lichtenstein shed ironic light on this cult of the brushstroke, prompted by the work of Jackson Pollock and others. At the same time he undermined the very definition of modern art, which rests on artistic originality and the potential uniqueness of every work of art. Lichtenstein has isolated the brushstroke from its painterly context, enlarged and simplified it by means of projection, and reproduced the result in the standardized language of the mass-produced printed cartoon. *Yellow and Green Brushstrokes* presents two superimposed swaths of the brush, including a few drips. As simple as the composition may seem, its structure is actually quite complex. It is one version of the subject among many. The source of the first version in the series was actually a comic drawing. Yet every further variant was the result of exhaustive experimentation, a process of trying, testing and inventing until the definitive form had been found. What appears to be a spontaneous, dynamic, well-nigh accidental configuration is actually the product of an ambitious mechanized procedure. Yet the images in this series find their true fulfilment only in printed form, as silkscreens. The silkscreen technique replicates the symbol of individuality. In these works, moreover, Lichtenstein raises the question of the difference between commercial trademark and artistic style. The *Brushstrokes* obviously blur the distinction to the point of unrecognizability. How, one might ask, does an incessantly repeated, identifiable mark in art differ from a standardized, industrially produced symbol?

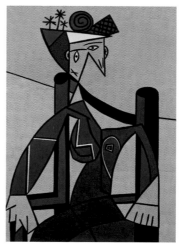

Femme dans un fauteuil, 1963

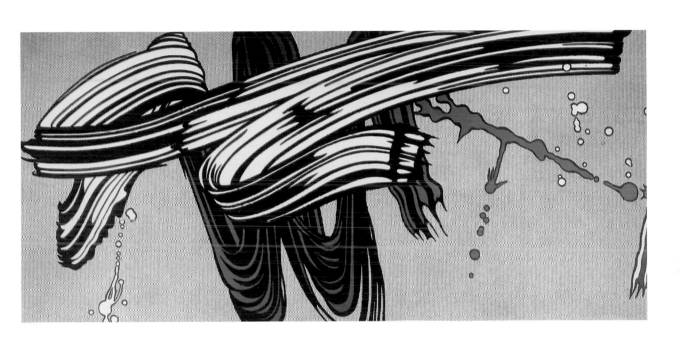

pastry case 1

Burlap and muslin soaked in plaster, painted with enamel, in glass-and-metal case, 52.7 x 76.5 x 37.3 cm
New York, The Museum of Modern Art, Sidney and Harriet Janis Collection

Oldenburg objected to all too high-flown interpretations of his work. The foodstuffs, he wrote about this collection of pastries in a showcase, were naturally not edible. A little thought was enough to reveal that they were not real but manifestations of art that were self-sufficient rather than serving purposes of any kind. Oldenburg took nine different products of an average pastrycook's imagination, made plaster versions of them, and painted some in an Expressionist manner. A blueberry pie, a few scoops of ice cream, a toffee apple, a ba-

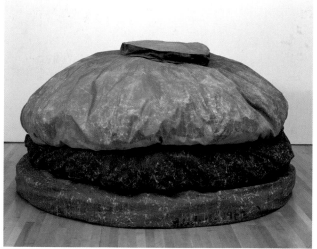

Floor Burger, 1962

nana split, arranged on plates or platters – traditional products often advertised as "home made", yet mostly straight from the factory. In the present case, however, they are truly "hand made", by the artist. Most of these supposed delicacies were shaped of coarse canvas or muslin, dipped in plaster, spread over a wire framework, and finally painted. The difference from the originals is immediately obvious. Neither in terms of form nor colour is any exact resemblance to food strived for, quite unlike, say, the astonishingly real-looking wax displays in Japanese restaurants. Rather, we gain the impression that the artist's miniature sculptures were primarily intended as parodies of Expressionist painting and sculpture. On the other hand, he alludes to the great tradition of Netherlandish still-life painting, those magnificent depictions of poultry, fish, hams, vegetables and fruit which, apart from physical enjoyment, celebrate the skill of the artists and moreover, in the manner of conspicuous consumption, shed light on the hedonism of their clients and the shadow of *memento mori* it casts. Yet Oldenburg's acid humour warns us against overestimating such links: "I am for the art of … sat-on bananas", he once declared. By the way, *Pastry Case I* is a key document in the history of Pop Art. It is a re-creation of a work in the legendary show "The Store", held in the Green Gallery in Manhattan in 1962. The dealer Sidney Janis purchased it there for $324.98 and included it in his renowned Pop exhibition "New Realists", which opened on November 1st of the same year. This exhibition brought together American and European Pop artists such as Lichtenstein, Oldenburg, Warhol, Klein, Arman and Niki de Saint Phalle. It is generally considered to have marked the international breakthrough of Pop.

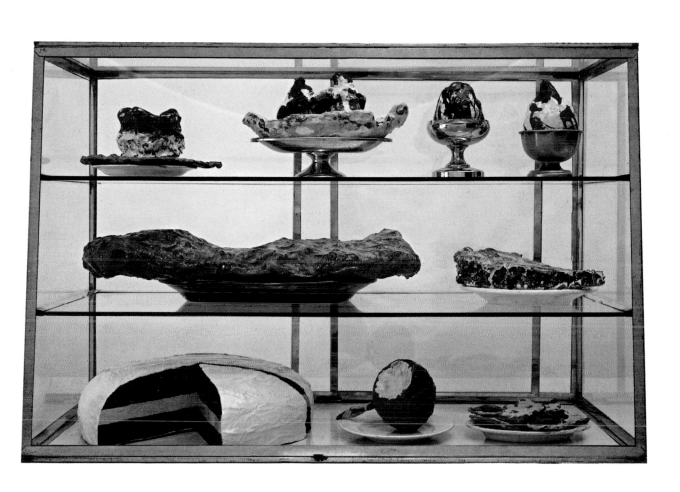

soft washstand

Vinyl filled with kapok, on metal stand painted with acrylic, 139.7 x 91.4 x 71.1 cm
Private collection

The associations suggested by the title of this piece and its actual appearance lie worlds apart. Anyone who has neglected to read the description will have to be very imaginative to recognize what this object represents. Using linen, wood, kapok (an upholstery material), and paint, the artist has created something normally made of porcelain, plastic and metal which serves mundane hygienic purposes: a wash basin on a stand. Instead of a compact, polished object with rounded or square corners, hard and solid in consistency, the viewer is confronted with a limp, rather grimy-looking configuration that could never hold water if one tried to fill it. Only the faucets appear substantial, although they are made of wood rather than metal. The supplement to the title indicates that this soft sculpture is a version in cloth. Other versions exist as well, for instance in vinyl and painted plywood. Although modelled on an ubiquitous home fixture and feature of modern civilization, Oldenburg's consciously imperfect imitation was not intended to address social or cultural aspects or relationships. It was intended as an aesthetic object whose effect owes solely to the circumstance that it is a work of art. Thus the gap between designation and function. While the explanatory adjective in the title aptly describes the character of the object, the noun is misleading, since it conveys the impression that the object fulfils a practical function. Already on this semantic level, a contradiction arises which suffuses the entire work. A soft washstand can never fulfil its designated task, just as little as a work of art can fulfil a practical function. It is no coincidence that Oldenburg is viewed as one of the precursors of Conceptual Art. Yet because his complex works aim at an effect involving a confusion of opposing sensations – what is hard becomes soft, solid things begin to flow – they form a bridge to an art beyond the avant-garde. A tendency underscored by his veritably Old Masterly drawings. In addition to home appliances, food represented one of the main sources of inspiration for this artist, who collected his first experiences as an initiator of and actor in happenings.

b. 1929 in Stockholm, Sweden

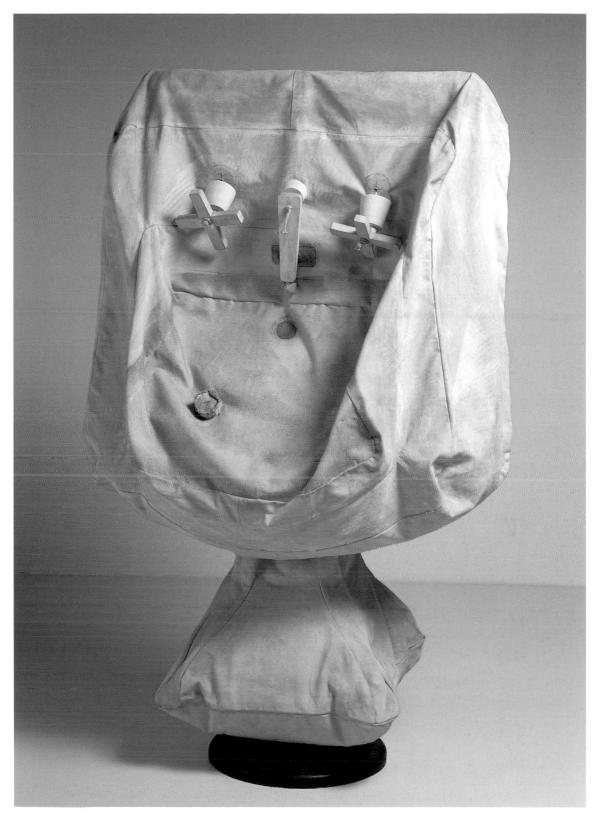

Giant Fagends

Canvas, urethane foam, wire, painted with latex in "ashtray" of wood covered with formica,
58 x 259 x 225 cm
New York, Whitney Museum of American Art,
Purchased through the Fund of the Friends of the Whitney Museum of American Art

Evidently Oldenburg is an artist who is moved to reveal the monstrous traits of ordinary mundane objects and common consumer goods. To this end he employs various yet analogous artistic devices, either replacing the original material of the object by one of a quite different character, or blowing it up to gigantic proportions, which automatically entails an alteration in material. Foods metamorphose into plaster lumps, sanitary fixtures into limp cloth hangings, and household appliances into instruments for a race of giants. A type of plastic, urethane foam, was used to make the crushed-out filter cigarette butts in *Giant Fagends,* which the artist piled on an inclined polygonal base measuring two-and-a-half by two-and-a-half metres. Altered in terms of form, substance and dimensions, these tobacco products are divorced from their normal everyday context and raised with the aid of a pedestal to the status of autonomous object of art. When viewed from close quarters, the object is not immediately recognizable as an enlarged rendering of a full ashtray. Not even the colours, ranging from white through ochre to blackish-brown, suggest the presence of waste; rather, they have a subtle, well-nigh elegant, elegiac effect which stands in strange contrast to the subject depicted. The sculptural perfection of the object does not jibe with the notion of smelly, dirty cigarette stubs. Such contradictions are the elixir on which Oldenburg's works thrive. Material and meaning conform as little with each other as form and content. This incongruence reveals the contradictions of modern civilization in a flash. While it infuses intellectual and aesthetic values into cheap consumer goods, Oldenburg ennobles trivial things to the rank of art.

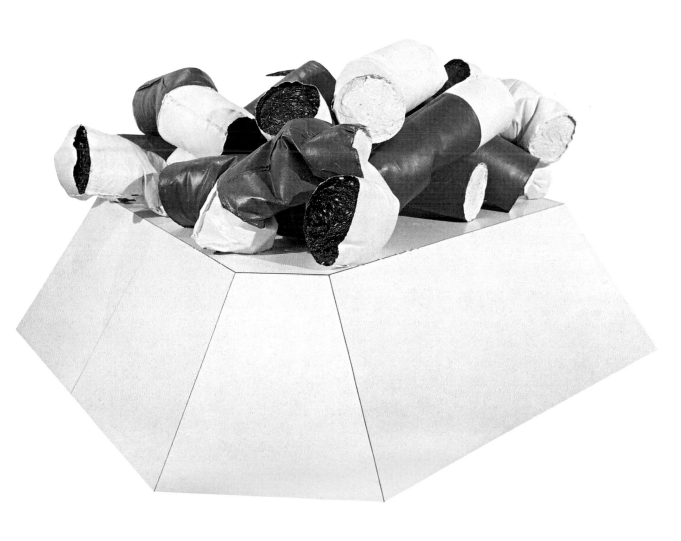

Lion versus Eagles

Oil on canvas, 213 x 153 cm
Ghent, Museum van Heedendaagse Kunst

Although he is considered the most American of British Pop artists, Phillips took the European tradition as the framework for his paintings. He looked far back into history, to a period before the renewal of art brought about by the Renaissance. In view of the formal nature of his preferred iconography – as in the present combination of lion and eagle, two mythological creatures, in a single visual context – Phillip's explanation seems surprising. Obviously his visual language was derived from the storehouse of popular culture. The stereotypical character of the depiction, drawing and palette leave no doubt about this. On the other hand, he has arranged the elements in this early composition in the way that medieval artists used to tell the stories of the Bible, in simple, separate fields that occasionally overlap at the edges. Phillips describes his pictures as combinations of spatial, iconographic and technical factors working together in a single motif. In pre-Renaissance painting, he adds, there is a complex visual situation with a central image and other, related scenes depicting a story or a phenomenon. The centre of the present composition is occupied by two lion's heads in a circle. They are approached by an eagle with

mighty wings, depicted against a dark-green background. These are likely familiar manufacturing trademarks that consciously allude to the mythological significance of the animals and their symbolism of courage and power. Today mythology no longer serves its erstwhile function of explaining the world, but is merely exploited to create an effective image for commercial products. The ensemble is topped by schematically rendered rays in alternating red and yellow, and two discs enclosed in triangles, below them two stars, yellow and black on a white ground, both labelled STAR. Despite its figurative forms the painting has an abstract appearance. It is executed like a blueprint, yet the things depicted do not go with one another. It is solely their arrangement, repetitions and correspondences that lends them aesthetic plausibility. In *Lion Versus Eagles* – a title, incidentally, that reverses the visible fact – a sort of integrative visual model of narration comes into effect which is quite different from that of Renaissance art. A model whose content, rather than being conveyed by a sequence of images, results from a merger and interweave of heterogeneous visual elements.

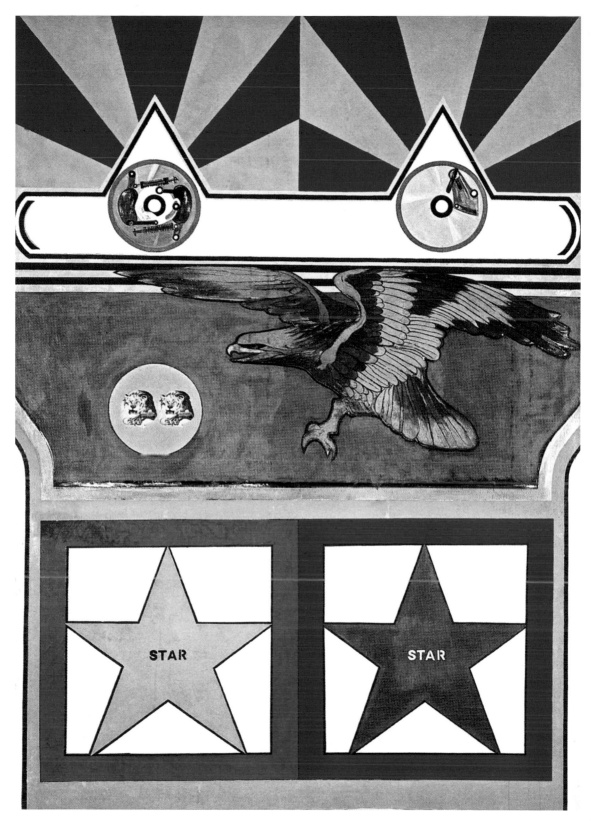

custom painting no. 5

Oil on canvas, 172 x 300 cm
Private collection

The unusual format of this painting itself suggests that the artist had mass-media effects in mind when designing it. Cinemas of the day resorted to similarly oversized pictures in an attempt to retain audiences in the face of the rapid spread of television. As if from a projection screen, an abundance of heterogeneous visual impressions storms the viewer, a tangle of rotating shapes that at the same time seems to form a visual correspondence to the high-volume sound of the cinema experience. Yet the visual context here was not determined by the time dimension of film. The British painter has juxtaposed and superimposed the separate elements of the composition on the two-dimensional plane of painting, whose laws govern the plausibility of the result. At the upper left, admittedly, the point of a high-heeled shoe, on the foot of a pin-up girl whose figure descends diagonally to the right, disturbs the integrity of the rectangular plane and simultaneously emphasizes the object character of the painting. The girl glances at us out of the corner of her eye, as if in passing. The rest of the surface is occupied by all sorts of things – a sectioned turbine, the grille of an American car, a technical drawing of a spark plug. Plus an orange octagon, a wavy band in the complementary contrast of red-green, a purple zigzag, and a square stood on one corner with an oscillating chequerboard pattern. All of these diverse motifs are brought together on a ground rendered in gradations of yellow. Flatness and plasticity interweave – with the exception of the pin-up girl, the swelling volumes of whose body are depicted with the naturalism expected of a professional illustrator, head and torso in photographic black-and-white, legs in white and red. The puzzle of motifs and their montage-like interlock recall the game window of a pinball machine, with the complementary contrasts of red-green, violet-orange and blue-yellow evoking the flickering lights behind it. Fun, sex, technology, the trademarks of consumer society, are all concatenated in this turbulent picture. During his second period of study at the Royal College of Art in London, Phillips met Allen Jones (with whom he would later travel to the U. S.), Boshier, Caulfield and Hockney, who formed the third and best-known phalanx of British Pop artists.

**b. 1939 in Birmingham,
Great Britain**

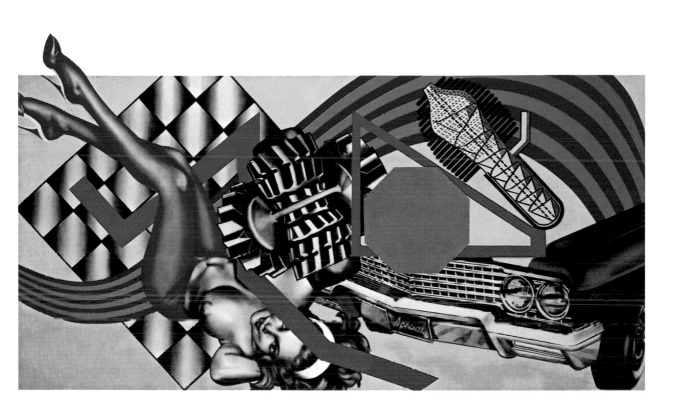

velveeta

Oil on canvas, 152 x 178 cm
New York, Collection Louis K. Meisel

The term "pin-up" derives from the practice of factory workers, soldiers, or truck drivers of mounting pictures of pretty girls in their lockers or cabs, to bring a little pleasure into their mundane lives. The painted versions of these are invariably based on photographs. Marilyn Monroe, too, began her career as a pin-up girl. The clientele for pin-ups is male, and mostly lower-middle class. A girl with an inviting look in her eye, sensually open mouth, long legs and ample breasts is one stereotype of the genre, and her counterpart is the apparently shy girl attempting to conceal her charms from unwanted glances. Both are products of male sexual fantasies, and tailored to a man's world. In the hierarchy of visual arts, pin-ups are considered a bit more vulgar than sentimental or martial comics, the sources Lichtenstein exploited, or labels on detergent boxes or soup cans, which Warhol reduplicated dozens of times. Yet they, too, received artistic honors in Pop Art.

It was a painter from California who paved pin-ups' way into the museum. Mel Ramos, alongside Thiebaud and Ruscha, is a representative of Californian Pop, and in terms of attitude, he is no less radical than Ruscha or Warhol. In his eyes, there is no basic aesthetic difference between serious and trivial art. Nor does he make any distinction between commercial and non-commercial art. After beginning, like Warhol, with an apotheosis of comic-book heroes such as Batman, Ramos turned to the female denizens of calendars and glossy magazines. With his paintings, sex at long last re-entered the field of fine art, ending an abstinence caused by abstraction. At the dawning of the "sexual revolution" and in the shape of aseptic sex, there began a renaissance of lust that was mobilized by advertising to sell products.

In *Velveeta,* a package of processed cheese serves the svelte nude model as a pedestal. The figure's treatment recalls a nude by Canova, presenting her comely back as she turns her perfectly coiffured head to give the viewer a languorous glance. The precisely reproduced label of the commodity and its form possess the same aesthetic value as the smoothly rendered body with its dimpled buttocks. Thanks to this combination of disparate elements, the image creates an absurd frame of reference with a slightly surreal flavour, and subliminally conveys the cynical message that personal happiness can be had only through an incessant consumption of surrogates, like pin-ups or factory-made foodstuffs.

b. 1935 in Sacramento, California, USA

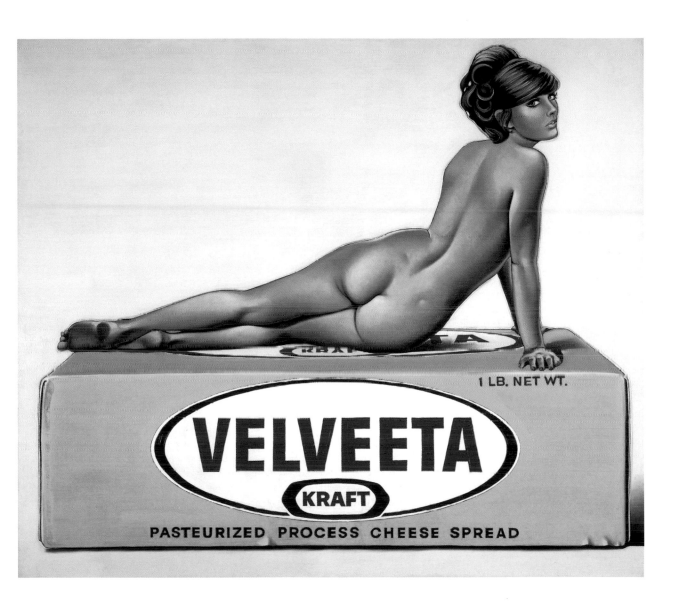

вlack мarket

Canvas, wood, metal, oil paint, 152 x 127 cm
Cologne, Museum Ludwig

==

Attached to the point of the traffic sign reading "ONE WAY" is a cord that connects the canvas with a dark, wooden box lettered "OPEN" on the floor. Painting was equally a part of life and art, Rauschenberg once declared, and established his position as an artist in the gap between them. The cord might be seen to embody his stance. It connects heterogeneous things, both actually and symbolically. Various mundane objects are affixed to the canvas in an aesthetically interesting way. The central horizontal axis is emphasized by four notebooks with painted metal covers. These vie for attention with the street sign that literally leads the eye "one way". The surface also contains a photograph of the dome of the Capitol in Washington, D. C., a car licence plate, and scattered digits and letters. These things are overlapped, tied together and accentuated by passages of spontaneous brushwork, which perform the same function as the cord for the three-dimensional objects. Rauschenberg aptly called the series of works to which *Black Market* belongs "combine paintings". He brought art, which had been spirited into the realm of the sublime and absolute under the aegis of Clement Greenberg and abstract painting, back down to earth by subverting the rigid categories and aesthetic theory of the avant-garde. Just the fact that his works were neither pure paintings nor pure sculptures, but united both disciplines, reflected the tendency of Rauschenberg's intentions. A friend of the composer John Cage and the dancer Merce Cunningham, and a former student of Josef Albers at Black Mountain College, Rauschenberg organized key happenings and participated in others before beginning to concentrate on space and plane. He is considered one of the forerunners of Pop Art. Yet although his art incorporated much of what would be exhaustively treated by Pop – such as the symbols of transportation and typography – its thrust was different. It was not on the glamorous aspects of urban civilization that the artist cast his eye but on the used and discarded, things whose glamour had been tarnished, if they ever possessed it at all. His works lend new dignity to the unspectacular, and in retrospect they appear to have much more in common with Abstract Expressionism than with Pop Art.

b. 1925 in Port Arthur, Texas, USA
d. 2008 in Captiva Island, Florida, USA

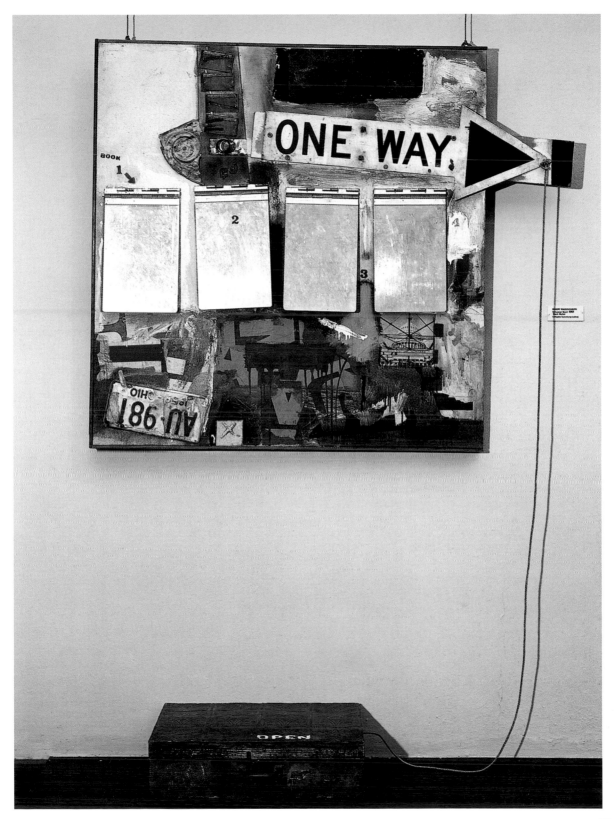

untitled (Joan crawford)

Oil on canvas, 92 x 78 cm
Cologne, Museum Ludwig

The shadow that fell on the great movie star's reputation was cast by her own daughter, who posthumously described Joan Crawford as a "bad mother" in a detailed book. Everything was secondary to her career, she stated, not only her private life but her little daughter. Crawford had often played career women on screen, hard, goal-oriented and successful, in a strange symbiosis of art and life, thirty years before Rosenquist portrayed her. But is this really a portrait, or just the opposite? The painting was based on a magazine illustration, which was probably itself done from a photograph. In this image Crawford's external trademarks have hardened into an almost caricatural cliché: the wide-open eyes with plucked eyebrows and false eyelashes, the routine smile congealed into a lopsided grimace, the permanent-waved hair. Her face is a mask that stares beyond the viewer into the distance. The original ad was apparently for a "mild" cigarette, but the artist has cut off the text, leaving a likewise truncated cigarette in the star's left hand as an indication. In fact, Rosenquist has robbed the ad of its effect, its message and function. It surprisingly turns out to be a purely aesthetic phenomenon, a painted montage of various typefaces, positive and negative, a poster-like autograph card rendered in carefully gradated colours of the kind often found in soap ads. Various red and ochre tones against a background of grey and greenish bands set the colouristic scene. Rosenquist's canvas is doubtless a counterpart to Warhol's more famous depictions of Marilyn Monroe, from which it basically differs only in terms of a more painstaking rendering and the lesser degree of attention it attracted. The reason for this lies in the model. In art, Crawford's persona never underwent the transformation into an icon that Monroe's did, despite the fact that the two actresses occupied the same level in the Hollywood pantheon. Admittedly, Crawford was of an earlier generation. Her last great box-office success, *Whatever Happened to Baby Jane*, 1962, directed by Robert Aldrich and with Bette Davis playing her rival, already lay two years in the past when Rosenquist picked up his brush. In the meantime, the diva had switched to a managerial career in the beverage business. And unlike Monroe's, her career was for the most part of her own making rather than being determined from outside. Crawford embodied the type of the emancipated woman – in both fiction and reality. And because Rosenquist's painting is not a portrait, it tells more about the mechanisms of the entertainment industry that transforms human beings into images than about the psychology of its sitter.

b. 1933 in Grand Forks, North Dakota, USA

standard station Amarillo, Texas

Oil on canvas, 165 x 315 cm

Hanover, New Hampshire, Hood Museum of Art, Dartmouth College

When he arrived in Los Angeles from Oklahoma City, Ed Ruscha was bent on acquiring the skills that would qualify him for a career in commercial art. He enrolled in the Chouinard Art Institute, a renowned school that had produced many illustrators for the Walt Disney Studio, but also had artists like Robert Irwin and Billy Al Bengston on its teaching staff. As Ruscha often recounted, it was seeing a reproduction of one of Jasper Johns' *Target* paintings in the journal *Print* that caused him to turn to fine art. Yet his interest continued to focus on the world of commerce, and he transferred the techniques and means of depiction of the standardized, mass-produced insignia of popular culture into the field of serious art. Besides Warhol, Ruscha is one of the most significant of Pop artists. The two share more than superficial formal links in common. *Standard Station* represents the sum total of all of the filling stations along Route 66, which runs between Ruscha's home town and the centre of the entertainment industry. While driving this highway several times, he made very straightforward, unpretentious black-and-white photos of the stations and published them in a slim volume called *Twentysix Gasoline Stations,* in a limited edition of 400. According to the artist, it was a wordplay that gave him the idea for the title, especially the combination of the number "twentysix" with the term "gasoline". Ruscha is the only Pop artist to have used the medium of photography without altering it to his own ends – in the form best suited to it, namely the illustrated book. A mechanical reproduction technique also underlies the colour print on the canvas *Standard Station.* The concept of "standard" takes on an ambivalent meaning here, since it applies both to the subject depicted and its industrial character, as well as to contemporary art in general. The word hovers as a brand name over the roof of a standardized gas station and four equally standardized red pumps. The hard-edge contours of the architecture stand in sharp contrast to the soft transition between horizon and sky – one of the most common, standard devices of traditional painting. Using the simplest means, the artist condenses the visual clichés of the everyday environment and the clichés of art into an exemplary Pop image on the most advanced technical level.

b. 1937 in Omaha, Nebraska, USA

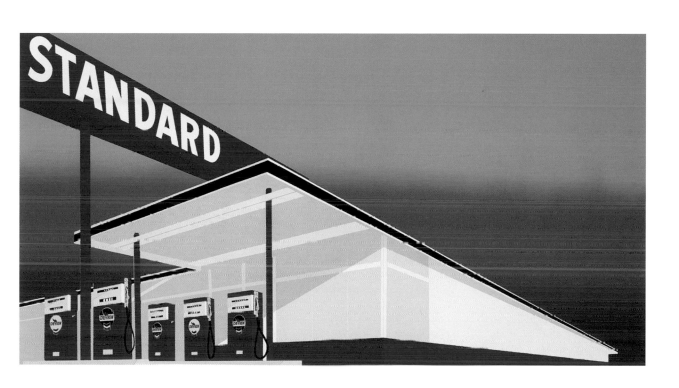

Hollywood

Silkscreen print, edition of 100, 31.6 x 103.5 cm
Private collection

Myths elude depiction in visual art. Yet sometimes myths crystallize around visual images, and sometimes they engender them – as in the case of icons, which are believed by the faithful to truly embody the figure depicted, or in the case of movies, with their sheer visual power to convince. Ancient myths actually represent collective memories formed in ages prior to the invention of writing. They belong to the realm of oral narration. Modern myths, in contrast, are collective fabrications of an industrial character. They form around manufactured commodities, automobiles, ships, railways, and occasionally around places or regions. But above all they form around the Dream Factory, as motion pictures were once known. Some film stars have taken on virtually mythical proportions – Greta Garbo, Gloria Swanson, Marlene Dietrich, Humphrey Bogart, Ava Gardner, Marlon Brando, James Dean, and Marilyn Monroe, following her premature death. Yet most Hollywood stars have merely reached the status of idols. Pop Art is the art that has intensively concerned itself with modern myths. Warhol contributed to the nimbus that now surrounds Monroe; Wesselmann and Rosenquist augmented the cult status of the VW Beetle. Ruscha, who lives quite near Hollywood, set out to visualize the myth of the movie metropolis. He produced several versions, for instance reproducing the animated trademark of one of the great studios, 20th Century Fox, or depicting the illuminated letters HOLLYWOOD jutting over a dark, hilly horizon before a morning (or evening) sky, both nearby and distant, as if surrounded by an aura. At the upper edges the letters shine so brightly that they almost merge with the dazzlingly bright sky, only fine shading setting them off. The artist is a specialist for the visual effect of lettering and onomatopoeic words. By means of refined rendering, he gives these a resounding meaning they do not actually possess. Hollywood! Hollywood! In view of Ruscha's picture, one speaks the name softly, with a measure of awe. *Hollywood*, this silkscreen print in an unusual cinemascope format, calls up all the fantasies we associate with the movies. Quite in keeping with long-forgotten aesthetic theories, Ruscha mobilizes the viewer's imagination, knowing that art takes place in our own minds. It is no coincidence that he is considered a leading figure in Conceptual Art, which only goes to show that many differences between classical and modern art are really no more than superficial.

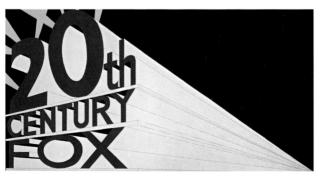

Large Trademark with Eight Spotlights, 1962

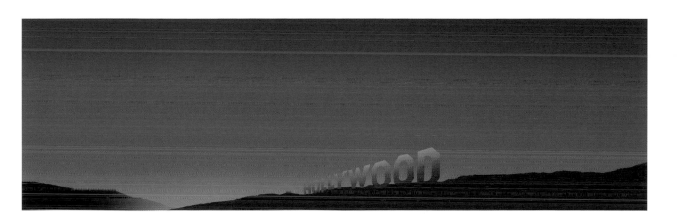

woman washing her Feet in a sink

Plaster, wash basin, chair; height: 152 cm
Cologne, Museum Ludwig

Originally Segal was a painter, for ten years. Disappointed by the limited possibilities of painting to evoke three dimensions, he turned to sculpture. The impulse to change his field of art leaves little room for speculation as to what sort of painting Segal practised. At any rate, he remained true to his artistic convictions, in sculpture, too, adhering to an empirical approach. It would neverthless be misleading to associate him with that current which, primarily in Europe, is known as realism. Realism is merely one of many frameworks within which an artist can deal with reality. Segal, in contrast, is more interested in reality pure and simple than in a vision that manifests itself in the form of an artistic statement. His attitude is shaped by the pragmatism of American culture. He had created a space, Segal once said, and that which strived to fill the space with a volume, which was known as sculpture. There could be no more concise statement of his aims. Segal made his first sculpture in the year 1958. *Woman Washing her Feet in a Sink* is another of his earliest works. It contains every trait that is typical of his art: a plaster figure, the immediate surroundings that define its existence in space, the real objects that anchor it in reality. Instead of artistically modifying things based on a certain notion of reality, Segal presents them in combination with the figure of the title, the only element subjected to aesthetic transformation. The figure was created from a living model, with the aid of plaster-soaked bandages. But rather than using the resulting hollow mould to create the final figure, as in conventional sculpture, Segal lent the provisional stage of the modelling process the seal of finality. The traces of the process of making remain visible. In consequence, a subtle relationship of tension develops between the plaster figures and real objects in Segal's sculptural ensembles, comparable to that between photographic image and photographed motif. Beyond this, a sense of oppressive loneliness engraves itself in our visual memory – the image of a woman of uncertain age in shabby surroundings, doing something in which nobody is particularly interested. Not a motif for voyeurs, and therefore not especially photogenic.

**b. 1924 in New York,
d. 2000 in South Brunswick,
New Jersey, USA**

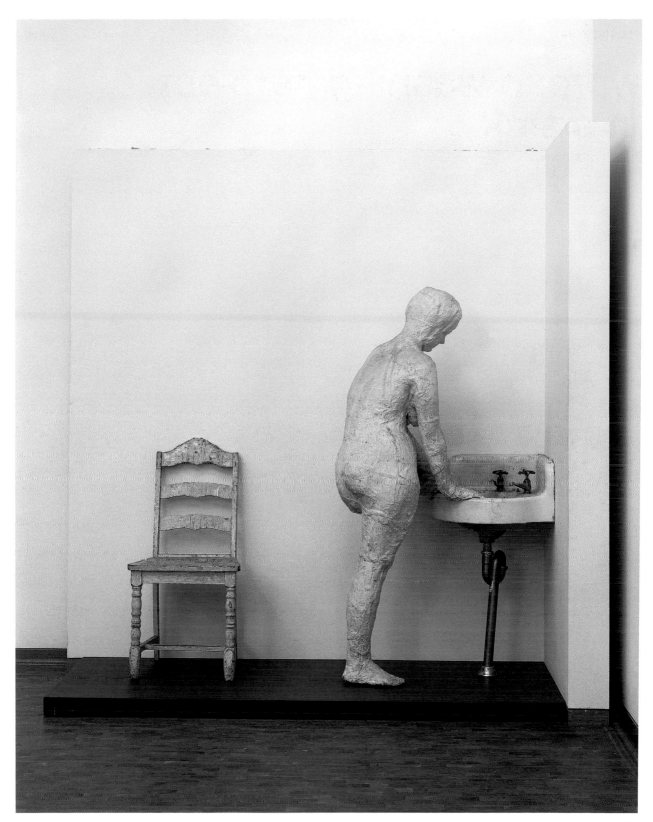

The Restaurant window

Plaster, restaurant window, wood, metal, Plexiglas, neon tubing, chair, table, 244 x 340 x 206 cm
Cologne, Museum Ludwig

A woman sits alone at an empty table in the window of a restaurant, as a man, lost in thought and hands thrust into his coat pockets, walks by. He has not yet passed the woman, but it seems unlikely that he will notice her, despite the fact that she sits in the restaurant window as if on display. The artist created the two plaster figures from living models. The remainder of the piece, as generally in his art, consists of real things – window, table, chair. The scene sends shivers down one's back. In a single "decisive moment", everything that contradicts the promise of commercial culture that happiness and fulfilment can be had through consumption comes together: the piercing loneliness of the individual in the shadow of the world of glamour and glitter. If the work can be said to have a connection with Pop Art at all, it is as a hollow or negative form, that is, due to its demonstrative lack of all the traits that characterize Pop. Within the Pop context, Segal's work is like a foreign body. It is rooted instead in a specific tradition of American art. The reference of the present piece to Edward Hopper's famous painting *The Nighthawks,* 1942, which likewise depicts a restaurant in the hours after dark, is obvious. The artist has merely reduced the number of figures and condensed the painting's ambivalent atmosphere to its naked core. On the other hand, the diner is one of the most significant institutions in American culture. Not the restaurant in the European sense, but what in the U.S. goes under the name of drugstore, bar, diner or drive-in. As sites of social intercourse, these places play an essential role in Hollywood movies. Paradoxically, Segal's version of Pop possesses a covert connection with its more typical manifestations in terms of technique. Most of his works have what can be called a photographic structure, being, as it were, materializations of ambitious photographers' mass-disseminated pictures. Like the man behind the camera, Segal freezes typical situations and constellations, and out of this condensation develops the crystallization point for a story that begins to unfold in the viewer's mind. He draws our attention to the dark side of a supposedly incessantly fun-loving consumer society, to people who cannot or will not participate in its diversions, the counter-image to the world evoked by advertising and glossy life-style magazines. At the same time, Segal gives convincing proof of the power of art to keep the gap between illusion and reality open. A retrospective of Segal's oeuvre, one imagines, would be no less than a nightmare.

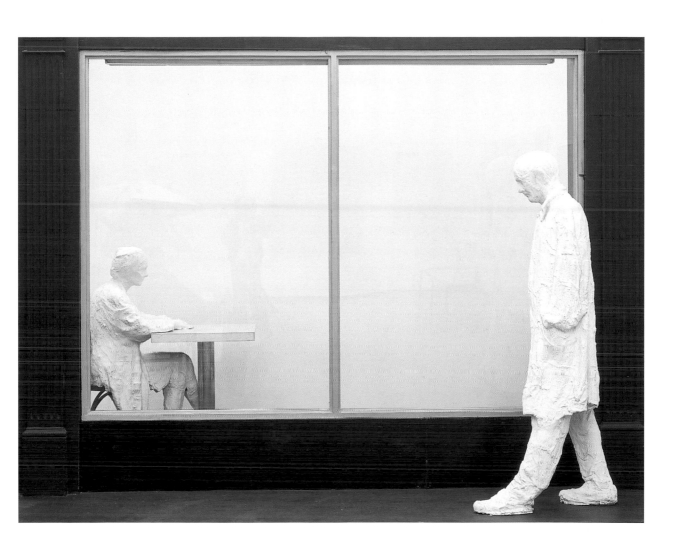

cake counter

Oil on canvas, 93 x 183 cm
Cologne, Museum Ludwig

As in a bakery window, cakes of various sizes and shapes are arranged to catch the observer's eye. The upper of the two shelves contains cakes with four layers, carefully decorated with off-white frosting. They recall the temples in the historical Hollywood movies of Cecil B. De Mille. Smaller versions with greater colour variations are displayed on the lower shelf, some of them already cut to reveal their luscious inside. Cut off by the picture edge on right and left, the two ranks of cakes seem to extend indefinitely beyond the frame. Their various hues emphasize the specific quality of the goods, and even though the blue may seem extravagant, it is not beyond a confectioner's skills. Creamy tones predominate, and of course the deep brown of chocolate and the bright white of whipped cream. The painting could be described entirely in gastronomical terms. At any rate, it re-establishes the lost ambiva-lence of the outmoded term "taste", once an aesthetic category, and subliminally recalls the loss to art which its reduction solely to visual stimuli has caused. Thiebaud is a representative of the Californian variant of Pop. The surface of his paintings reflects the process of making, for the brushstrokes remain clearly visible. The paint is not applied in a slick, anonymous, commercial-art manner, yet nor does it approach the subjective character of Abstract Expressionism. It creates an illusion of cakes and pies in a dual sense: by means of imita-tion (local colour) and through a heavy impasto that emphasizes, a bit obviously, the creamy physical consistency of cake frosting. Apart from the objects, the illumination plays a key role here. The light seems to cast almost no shadows. As the artist once said, he was in-terested in what happens when the similarity of colour and pictorial content was as great as possible, as when viscous brilliant white was applied to a painted cake like frosting. Thiebaud is a sort of Califor-nian Chardin who has cut his piece from the cake of art, and a Pop artist primarily by virtue of his choice of subject matter. That he is also a virtuoso painter can be seen from *Cake Counter,* which is bisected horizontally as if by a visual barrier. This lends the objects an incredible plasticity. Yet the formal unity of the composition is by no means pre-judiced by this canny disturbance.

b. 1920 in Mesa, Arizona, USA

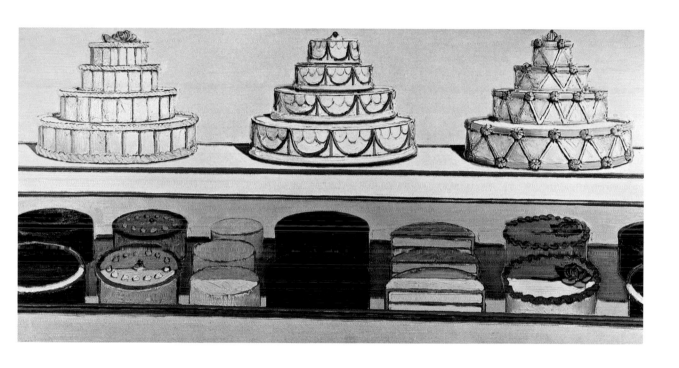

129 Die in Jet

Acrylic on canvas, 254.5 x 182.5 cm
Cologne, Museum Ludwig

On June 4, 1962, a Monday, the front page of the *New York Mirror* carried the screaming headline 129 DIE IN JET! Between the capitalized lines appeared a press photo, twice as large as the headline, showing a half-destroyed wing jutting into a cloudless sky, with a few policemen or rescue workers silhouetted in the foreground. Shortly after the disaster, Warhol used a slide projector to transfer the page to a canvas measuring 254.5 by 182.5 cm, and rendered it with brush and paint. Newspaper title, headline and illustration (complete with byline) make up a composition with which Warhol introduced the series of what he termed "death paintings". These, in contrast to the celebration of the American Way of Life in many of his other works, shed glaring light on its seamier side. The letters of the headline have a tremendous visual impact. In subsequent works Warhol would create a similar effect by repeating a single image over and over again. The suggestive force of the capital letters and painted photograph are difficult to resist. Both get under our skin despite the fact that airline disasters have since become an almost daily occurrence. Warhol's treatment of the press photo adapts it to the graphic presence of the lettering, and reduces the details of the photo reproduction to a few characteristic abbreviations. This increases the tendency to abstraction already present in the enlargement. The few artistic incursions create a distance to the original, and to the event itself, divesting the painting of any suggestion of embarrassing realism and raising its message to an exemplary level. At the same time, they heighten the print-image combination into a timeless symbol. The mediated reality of the yellow press is sublimated into the reality of art, leaving mental associations to the viewer's imagination. The idea for the picture was suggested by Henry Geldzahler, then curator at the Metropolitan Museum of Art in New York and one of the few advocates of Pop on a museum level at the time. Warhol was having breakfast with Geldzahler in a Manhattan restaurant. The curator was reading the *New York Mirror,* whose title page, Geldzahler reputedly said, would make a good subject for a painting. Warhol was always receptive to suggestions from others; in fact, they were an integral part of his aesthetic principles. His founding of a "Factory" to produce pictures a short time later was not only prompted by commercial considerations but reflected an aesthetic stance in which the contemporary artist figured not as a lone genius but as a sort of catalyst for diverse outside influences.

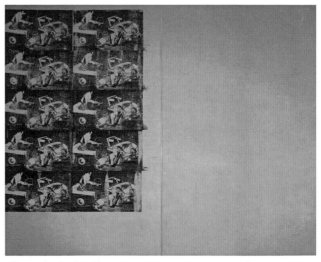

Orange Car Crash 10 Times, 1963

FINAL ★★ 5¢ New York Mirror

WEATHER: Fair with little change in temperature.

Vol. 37, No 296

MONDAY, JUNE 4, 1962

C

129 DIE

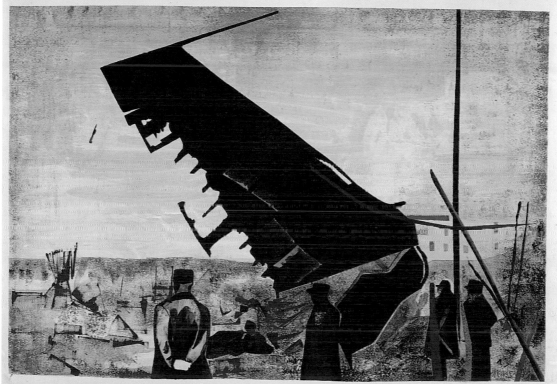

(UPI RADIOTELEphoto)

IN JET!

gold marilyn monroe

Polymer, silkscreen, oil on canvas, 211 x 145 cm
New York, The Museum of Modern Art, Gift of Philip Johnson

Andy Warhol may have contributed more to Marilyn Monroe's myth than Hollywood and the glossy magazines put together. Commerical movies and their public relations campaigns merely made her into a sex symbol and the prototype of the dumb blonde. She suffered under this image, as her various biographies, both fictitious and authentic, have since made clear. People laughed at Marilyn's ambition to be taken seriously as a thinking and feeling person, with only few exceptions. Her desire to play dramatic roles after successfully taking courses at the famous Actor's Studio in New York was looked upon as an infringement of the rules by the movie industry. Shortly after her death in 1962, possibly as a result of a fateful error, Warhol transformed a quite mundane publicity photo, taken by the American photographer Frank Powolny in the early 1950s, into an icon of popular culture. When the picture was taken, Monroe had just managed to escape the pin-up calendars and postcards, much appreciated by G.I.s, for which she had posed while working in the armament indus-

b. 1931 in Pittsburgh, Pennsylvania,
d. 1987 in New York, USA

try. Thanks to notable minor roles in John Huston's *Asphalt Jungle,* 1950, and Joseph L. Mankiewicz's *All about Eve,* 1950, she had made her mark in ambitious Hollywood films. Yet Monroe was never entirely able to escape the label of sex bomb. Apart from her attractive figure, the movie industry merely exploited her comic talent, but continued to deny her the honour of being a serious actress. *Bus Stop,* 1956, by Joshua Logan, and *The Misfits,* 1960, another Huston film, were the only major roles that gave Monroe a chance to prove her dramatic talent. Many contemporary movie stars enjoyed greater reputations, in public as well as on screen, than she. It was only after her death that her true fame began; in fact, death seems to have been a condition for it. By placing the uninteresting photographic portrait with its forced, stereotypical smile in an expansive space that surrounds it like a dignified frame, and covering the whole field with gold – the colour of the Heavenly Jerusalem, which lends icons their supernatural effect – Warhol idolized it. The arched lips, the eyes, curly hair and face, deprived of volume and realism by the silkscreen technique, detach themselves from the background and float in front of and above it like stars in a golden sky. In many later versions, Warhol secularized the idol by constantly repeating or isolating the smile, and linked the myth of the star with the methods used by the mass media to make a star. By means of continually new variations and incessant sequences, as an industrialized product, a consumer commodity.

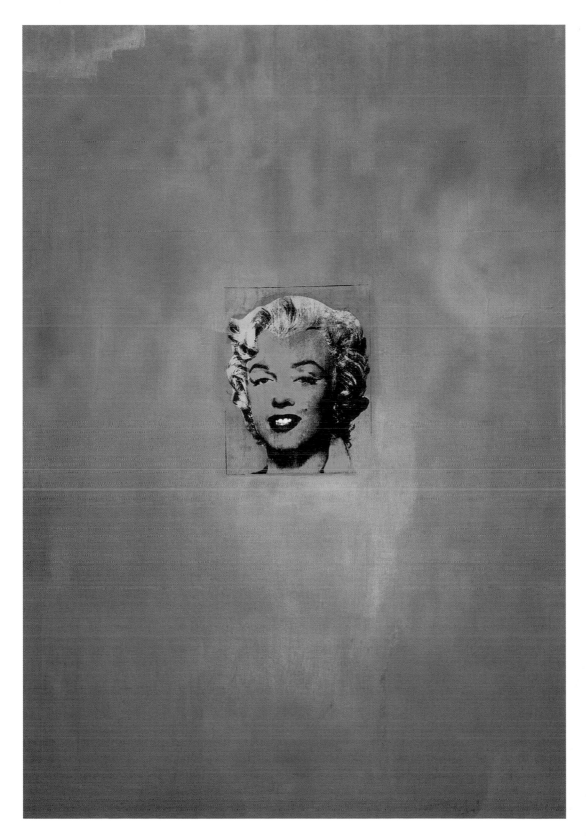

80 TWO DOLLAR BILLS (Front and Rear)

Silkscreen on canvas, 210 x 96 cm
Cologne, Museum Ludwig

Put in the simplest terms, the content of this picture is 80 dollars. This is its subject, and nothing else. Represented are 80 dollars, in units of 40, worth two dollars each. The artist has depicted their obverse and reverse sides, in ten rows comprising four bills each. To decode the work's content, we need only perform a little simple addition. Apart from this exercise, it demands no particular intellectual acumen, and the process of understanding runs a clear, rational course. Possible misreadings are excluded from the start. Nor need we fear that any potential observer might not be familiar with the motif of the printed canvas. It is as omnipresent as God in theocratic states. To this extent, the comparison with icons, which is used *ad nauseam* with respect to Warhol's pictures, would apply best to his long and varied series of dollar-bill depictions. God has merely been replaced by the material phenomenon of money – likewise a magical system based on faith. The dollar bills, too, embody – in the truest sense of the word – that which they represent: money. There is no fundamental gap between original and image, between real bills and the "counterfeit" bills applied to canvas with the aid of a silkscreen. Both represent an abstract system, a mercantile value that far transcends their actual, material value. With the difference that the mercantile value of Warhol's dollar-bill works is considerably greater than that of the value of the banknotes depicted. To realize this value, only a commercial exchange is necessary. No artist before him more mercilessly exposed the fiction of the incompatibility of intellectual and material values in the sphere of art than Warhol. At the same time, he shed harsh light on the interdependence of economic and cultural mechanisms in the art trade, and recognized this to be constituitive for the substance of a contemporary work of art. Contrary to legend, in other words, the value of a work of art is not measured by its aesthetic quality alone, whatever that may be, but equally by the price it can command and – not to be forgotten – by the prestige of its author. Successful circulation in the commercial art trade is an integral part of the artistic (not aesthetic) quality of a work. And every sale of one of Warhol's dollar-bill paintings fills its content with new life.

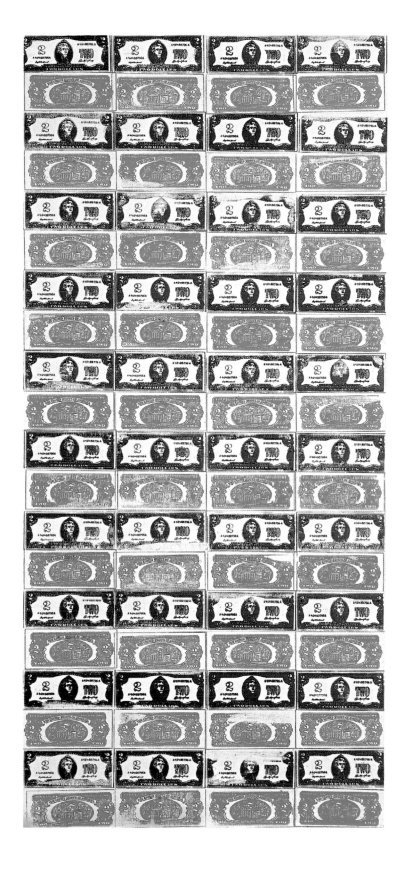

campbell's soup can 1

Acrylic, Liquitex, silkscreen on canvas, 92 x 61 cm
Aachen, Neue Galerie – Sammlung Ludwig

When Warhol first exhibited his pictures of Campbell's soup cans in July and August 1962 – thirty-two all told – he presented them in the way tinned foods are offered for sale in a supermarket, in orderly, evenly spaced rows. Quite in keeping with the guidelines of "product placement", in other words, commercially oriented aesthetic considerations. The site of the demonstration, however, was no ordinary supermarket in Los Angeles, but the Ferus Gallery, a pioneer in the propagation of Pop Art. The paintings cost 100 dollars each, compared with 29 cents for the original. In terms of technique, the pictures were a semi-mechanical product – a mixture of painting, silkscreen and a stamp process, practices partly manual and partly industrial in nature. Although a superficial glance revealed no differences between the individual, 50.8 x 40.6 cm images, they in fact differed in a key detail, each representing a different kind of soup, an individual taste beneath the monotony of the packaging.

The exhibition represented a conscious provocation, triggered not only by the mundane motif and its stereotyped depiction, but by the parallels purposely suggested between art gallery and supermarket, art trade and food trade. For Warhol, who had studied sociology, the social context in which a work of art is presented was just as important as its specific subject, and the subject itself invariably reflected its social background. Campbell's soups, Coca Cola, Kellogg's Cornflakes and Brillo detergent, industrially produced commodities of American civilization, lent the dignity of art by Warhol, shaped the life of the American middle class, of which he was part, as much as sex and death.

Campbell's Soup Can, a later, enlarged, and isolated version of the tomato soup can, might convey the erroneous impression that Warhol was out solely to apotheosize the idiom of popular culture. In fact its social effects were equally important to him. What made America fabulous, Warhol once explained, was that it established a tradition in which the richest consumers basically bought the same products as the poorest. You could watch television and drink a Coca Cola, and you knew the president drank Coke, Liz Taylor drank Coke, and there you were, drinking Coke, too. A Coke was a Coke, concluded Warhol, and no amount of money could buy you a better one.

This insight perhaps explains why he set out to achieve something similar in the field of art. With the aid of standardized production methods, Warhol infused art with the magic of the perpetually same. After photography had entered the cultural scene as the "great leveller" (Jonathan Crary), Warhol followed its cue in the field of art.

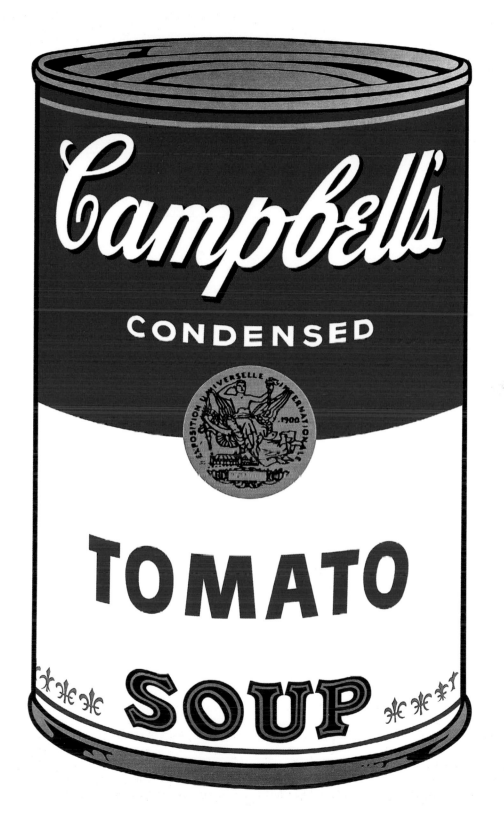

Bathtub 3

Oil on canvas, plastic, various objects, 213 x 270 x 45 cm
Cologne, Museum Ludwig

It would be hard to imagine a better ad for a bathroom for singles. Yet the only thing this picture advertises is the skill of its maker. An unusual work – a combination of painted and real things, including a door, towel, bathmat, laundry basket, shower curtain. In modern art such montages generally serve the purpose of counteracting any sense of illusion, as in Cubism. Here, this aesthetic principle serves just the opposite purpose – to increase the sense of illusion. The reality of the photographic rendering glosses over the difference between painting and reality. Only the flat silhouette of the naked blonde woman drying her back with a red-and-white striped towel indicates the artificial character of the arrangement. Her nakedness is in fact largely the product of the viewer's imagination, since it is only suggested by subtly rendered nipples and pubic triangle. Wesselmann plays a canny game with various levels of reality, bringing products of the real world as counters into the game. Not even the bather's silhouette corresponds to a conventional silhouette, being white instead of black. In fact, the supposed silhouette is a template, equipped with obvious sexual attributes: blonde hair, nipples, pubic hair, those neuralgic symbols which the male imagination invariably tends to flesh out. Yet the artist has set limits on the imagination by his choice of ambience. Sexual fantasies are confined to a clinically clean terrain. Nothing is present that would be prohibited in advertising. Once again, Wesselmann proves himself a skilled exploiter of the erotic world of Henri Matisse in the commercial climate of sexualized American popular culture. By entirely expunging the dark aspects of sexuality that reverberate in some of the French artist's paintings, he outdoes the art of his idol in terms of sheer artificiality. Paradoxically, he finds support in the set pieces he has lifted from reality. The real flips over into the sphere of the artificial.

b. 1931 in Cincinnati, Ohio, USA
d. 2004 in New York, USA

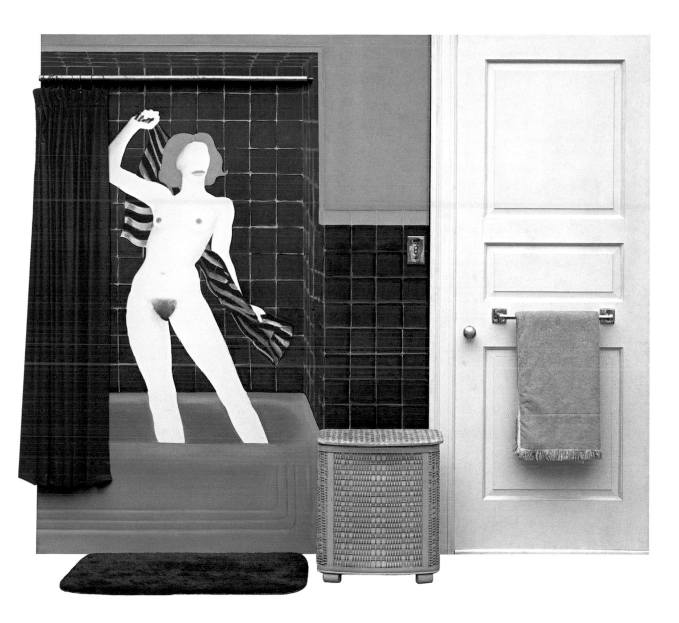

great American Nude No. 98

Five canvases arranged one behind another on three levels, 250 x 380 x 130 cm
Cologne, Museum Ludwig

Jean-Pierre Melville, the great French film author, once scoffed in conversation with Rui Nogueira that the female ideal of American men was "a woman who wears her behind on her chest". Tom Wesselmann frequently paid tribute to this notorious obsession with big breasts, which feature in a highly visible way in this picture-object consisting of five canvases. He has added a few related attributes: the model's long blonde hair, a temptingly open red mouth with brilliant white teeth and pink tongue, a luminous reddish-yellow orange with highlight in the foreground, and a smoking cigarette immediately in front of the jutting breast in the middle ground. A rectangular blue box of Kleenex tissues, a black ashtray and a semicircular cushion complete the ensemble. Thanks to the compressed arrangement of the three superimposed pictorial levels, the sexual attributes immediately strike the eye. And they are rendered in a highly schematic manner. The lack of individuality of the woman's face, and the smooth paint application lacking every trace of personal touch, signal the source of the artist's inspiration – advertising. Yet although his straightforward

effects were derived from its vocabulary, Wesselmann has altered the strategy of advertising in a decisive way. By means of exaggeration, instead of using sex to draw the viewer's attention to the surrogate satisfactions of consumption he presents it pure, and transforms the consumer goods depicted into sexual symbols in their own right. The incredibly refined colours lend the work a seductive force and gloss over the all-too obvious clichés. The result is a provocative tension, sensed just above the threshold of perception, which the artist has purposely factored into the equation. Before he arrived at his typical style, Wesselmann experimented with Abstract Expressionism à la Willem de Kooning, with collages based on abstract and mass-media sources, and with relatively conventional depictions of objects and landscapes. His experience with the collage technique – instead of painting from existing material like most Pop artists, he employed it unaltered – is immediately apparent in the characteristic structure of Wesselmann's brand of Pop.

still Life NO. 20

Mixed media, 104 x 122 x 14 cm
Buffalo, Albright-Knox Art Gallery, Gift of Seymour H. Knox, jr.

The Mondrian is a copy. The bottles, toast, bananas, apple, glass of Coke and table expand the chapter of *trompe l'oeil* in the field of art. Real, on the other hand, are the cabinet, its contents, the fluorescent tube, and the faucet with soap and soap dish. Out of paint, paper, wood and these consumer commodities, Wesselman has fabricated a cross between a kitchen and bathroom. Three levels of the real are interlocked in this assemblage: reality *per se*, photography and painting. However, photographic elements turn out to be painted, painted elements turn out to be coloured prints, and real things turn out to be elements of an art work, at least in light of the modernist definition of art. As soon as something is shown in a museum, the spotlights of art fall upon it and illuminate it as a work of art. On the other hand, the work of art included in *Still Life*, a framed copy of a Mondrian painting, takes on an aspect of the real, since its use as an item of interior decoration reduces its artistic meaning, causes its intellectual dimension to pale. The photographically rendered foodstuffs, finally, have the character of hallucinations, and the remaining things that of trivial pieces of decor, like the Mondrian copy.

Pop Art was never as linear as many critics maintain. The context in which works of art are perceived was often the underlying theme. The conditions in which a work is manifested influence its perception. Such tensions between the levels of the real are reflected in the formal tensions in Wesselmann's assemblage – the tension between illusionistic painting and actual object, between plane and space, between art and decor. After his *Nudes* Wesselmann turned to the subject of still life. And as there, he veritably conjugated this genre in an extended series of works. The focus of this series was no longer woman as object, but her domestic environment, the kitchens and bathrooms of middle-class suburban homes. The sexual connotations were toned down, but not eliminated, as the chance encounter of pointed bananas and round apples indicates. As a rule, fruit stands for male and female, phallus and breast, in Wesselmann's art, including *Still Life No. 20*. The sexual obsessions seep through the façade of respectable, prudish American life like butter through waxed paper.

To stay informed about upcoming TASCHEN titles, please request our magazine at www.taschen.com/magazine or write to TASCHEN America, 6671 Sunset Boulevard, Suite 1508, USA-Los Angeles, CA 90028, contact-us@taschen.com, Fax: +1-323-463.4442. We will be happy to send you a free copy of our magazine which is filled with information about all of our books.

© 2006 TASCHEN GmbH
Hohenzollernring 53, D–50672 Köln
www.taschen.com

Editor: Uta Grosenick, Cologne
Editorial coordination: Sabine Bleßmann, Cologne
Design: Sense/Net, Andy Disl and Birgit Reber, Cologne
Production: Ute Wachendorf, Cologne
Translation: John Gabriel, Worpswede

Printed in Germany
ISBN 978-3-8228-2218-0

Reference illustrations:
Page 54: Roy Lichtenstein, *Femme dans un fauteuil,* 1963,
Magna on canvas, 173 x 122 cm,
Berlin, Sammlung Marx, Hamburger Bahnhof – Museum für Gegenwart
Page 56: Claes Oldenburg, *Floor Burger,* 1962,
Painted sailcloth and foam rubber, 132 x 213 cm, Toronto, Art Gallery of Ontario
Page 74: Edward Ruscha, *Large Trademark with Eight Spotlights,* 1962,
Oil on canvas, 170 x 339 cm,
New York, Whitney Museum of American Art, Percy Uris Fund
Page 82: Andy Warhol, *Orange Car Crash 10 Times,* 1963,
Acrylic and Liquitex on canvas, 2 parts, each 332 x 206 cm,
Vienna, Museum moderner Kunst – Sammlung Ludwig

Page 1
ROY LICHTENSTEIN

Art
1962, Oil on canvas, 91 x 173 cm
Private collection

Page 2
JAMES ROSENQUIST

Marilyn Monroe I
1962, Oil and spray enamel on canvas,
236 x 183 cm
New York, The Museum of Modern Art,
Sidney and Harriet Janis Collection

Page 4
ANDY WARHOL

Brillo, Del Monte and Heinz Boxes
1964, Silkscreen on wood, 44 x 43 x 36 cm;
33 x 41 x 30 cm; 21 x 40 x 26 cm
Private collection